Watercolours by Hans J. Wegner

Watercolours by Hans J. Wegner

Anne Blond

Strandberg Publishing

Published with support from

POLITIKEN-FONDEN

Danish Arts
Foundation

Content

7	Preface
9	Wegner's artistic ventures
23	Historic furniture
35	Furniture
73	MoMA competition
81	Woodwork designs
99	Animals, figures and people
115	Buildings and landscapes
131	Interiors
151	Wallpapers
167	Objects
179	Biography

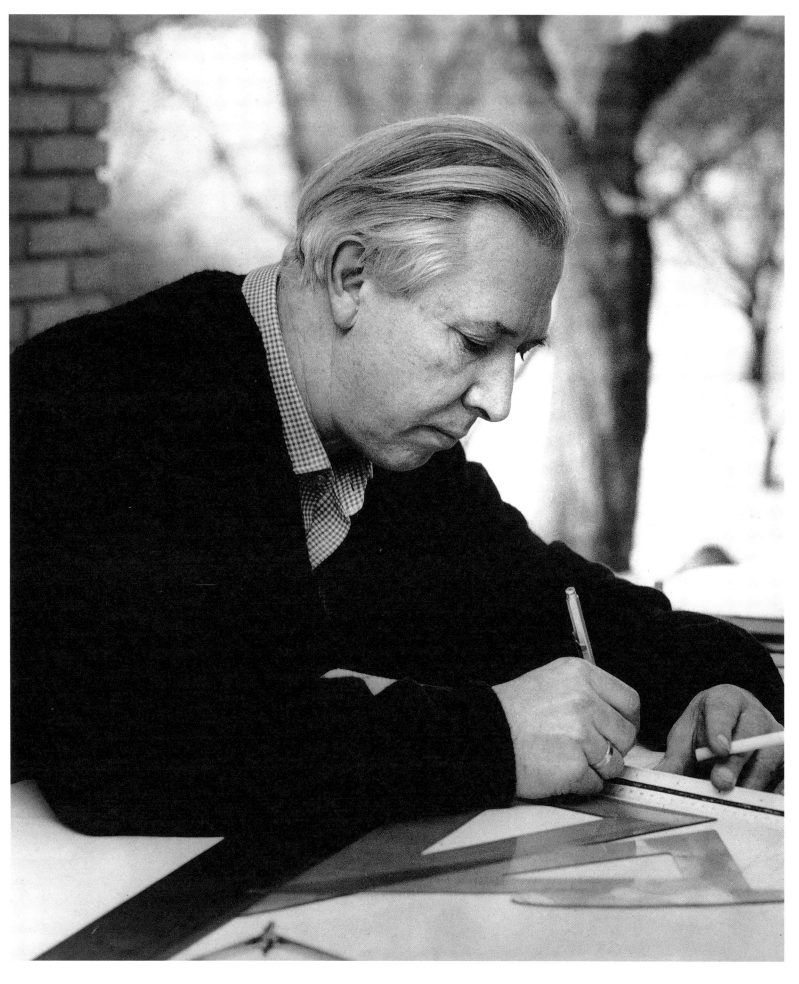

Preface

This book focuses on the watercolours created by the Danish furniture designer Hans J. Wegner (1914–2007). His watercolours constitute a relatively limited body of work: most of them date from his time as a student at The School of Decorative Art (Kunsthåndværkerskolen) in Copenhagen, where he studied furniture design. The rest primarily served as a work tool: he used them when making submissions for design competitions, when visualising interiors or preparing designs for furniture that incorporated particularly artistic elements, such as his Fish Cabinet.

Occasionally, however, watercolours appear in their own right within his oeuvre, serving no specific practical purpose. In these works, Wegner reveals a personal interest in the architectural culture of his home region of Tønder and especially in its distinctive marshland landscape.

When observing Wegner's watercolours within a wider perspective, one that also includes his few artworks and woodcarvings, there can be no doubt that the more artistic side of his creative talent formed firm foundations for his later status as one of the most important Danish furniture designers – possibly even the most important chair designer of the twentieth century, a title he himself proclaimed belonged to the American designer Charles Eames, who in turn bestowed it back upon his Danish counterpart.

On the one hand, Wegner preferred to explain his designs on the basis of the principles and logic of carpentry and cabinetmaking, and he professed that he did not think art was of much use in furniture production. Yet on the other hand, he also admitted that without his early exposure to art, the theme charted by the essay presented in this book, he might never have become a furniture designer.

Unlike several of his contemporary colleagues, Wegner never wanted to become a visual artist. Even so, he certainly possessed the requisite gifts for such a career, and art played a greater role for Wegner than he himself and posterity have given it credit for.

All the works reproduced in the themed sections inside this book originate from Hans J. Wegner's design studio. While the archives have been searched with great diligence, we cannot rule out the possibility that a few more Wegner watercolours exist beyond those reproduced here. Be that as it may, the range of works presented in these pages provides clear insight into the subjects addressed by Wegner and showcases his abilities with pigments, water and brush.

Warm thanks go out to Hans J. Wegners Tegnestue and to Marianne Wegner and Eva Wegner, who have kindly made the material available for this publication and who have read my words with their always critical, caring and constructive eyes.

In addition, a warm thank you goes out to everyone who contributed to making the publication possible: Politiken-Fonden, the Danish Arts Foundation, the board of Museum Wegner, Designmuseum Denmark, Rasmus Koch Studio, and the tireless editorial team at Strandberg Publishing.

Anne Blond

Wegner's artistic ventures

In 1965, the esteemed Danish furniture designer Hans J. Wegner set up a design studio in part of his house. It had very little on its walls besides a notice board – an indispensable tool of the trade for any draughtsman at the time. However, behind the door leading to the rest of the house, you would find some framed butterflies, tucked quite unobtrusively out of place. They emerge before us as relics from a distant past, a testament to a leisure activity dating back to the furniture designer's youth when butterfly hunting was considered a fun, innocent pastime. But perhaps they were also placed there as a testimony to one of the most important qualities Wegner was highly aware of possessing, a quality he acquired and honed during his formative years in Tønder: the ability to see.

'I believe he taught me to see,' said Wegner about Marius Jacobsen, his young teacher at Tønder Øvelsesskole. 'He collected butterflies, and I do think he taught me how to see.'[1]

Wegner could, of course, see perfectly well before this. He was alluding to his special sense for all things visual, his ability to perceive the world through his eyes with particular acuity and to condense and express these sensations with a balanced relationship between lines, shapes and colours to match the one with which a butterfly is born.

Wegner's well-developed ability to shape and proportion materials and devise colour schemes can also be described as an artistic talent. As a young man, he explored this gift through drawing, painting and wood-carving, and when he later became a student at The School of Decorative Art (Kunsthåndværkerskolen) in Copenhagen, his endeavours branched out into watercolour – a medium he continued to use as long as he needed to participate in competitions and market his skills through drawings.

However, as of the early 1950s, by which time Wegner had made a name for himself and his long-term collaborations with various furniture manufacturers had become established, the main elements propelling the creation of the four hundred to five hundred chairs he designed – several of which are rated as among the world's finest – were his tremendous carpentry skills seasoned with a playful experimental touch, an unending wealth of ideas and a staggering work ethic. After 1950, Wegner produced many technical drawings, but he rarely took the time required to colour in a drawing or to do a painting. His artistic abilities would occasionally find their way into his furniture designs, but that is a story for another day. Here we will focus on the period before 1950 and trace Wegner's artistic vein, of which the watercolours also became a part.

Artistic endeavours among Wegner's peers

In Wegner's day, it was not uncommon to see a budding artistic talent become the starting point for studying architecture and, by extension, entering the realms of furniture and interior design.

The architect Finn Juhl, whom Wegner knew from the Copenhagen Cabinetmakers' Guild (Snedkerlauget) exhibitions; Arne Jacobsen, under

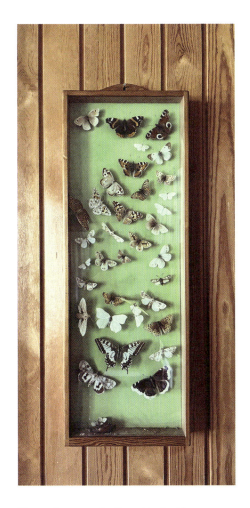

Wegner's own collection of butterflies.

whose supervision he designed fixtures and furniture for the Aarhus City Hall; and the Finnish architect Alvar Aalto, whose buildings Wegner specifically sought out on a trip to Finland in 1939, had all worked with fine art in their youth. Both Juhl and Jacobsen had at some point in their lives wanted to pursue a career as visual artists but were advised against it by their respective fathers. The reverse was true in Finland, where Aalto's family were favourably disposed to him becoming an artist, but he decided, of his own volition, to become an architect instead.

In Juhl's case, his fine-art practice receded somewhat into the background after his time at The School of Architecture (Arkitektskolen), but his keen sense of colour and proportion continued to find expression in the many watercolours of furniture and interior design projects that Juhl and his design studio produced over time. Juhl followed contemporary art closely, and at exhibitions as well as in his own home he saw great advantages in letting his furniture interact with sculpture and painting, offsetting them against each other. In the late 1950s, he even suggested to his employer at the time, SAS (Scandinavian Airlines), that they should invest in contemporary art for the various offices around the world that he had been tasked with decorating. There can be no doubt that his great interest in and knowledge of contemporary art had an impact on his designs and on the spaces he created as an architect. To his mind, architecture, art and design ought to have a clear knock-on effect on each other, jointly creating spatial totalities. Arne Jacobsen shared this attitude.

Jacobsen trained as an architect too, graduating in 1927, but unlike Juhl, he maintained a separate trajectory of artistic endeavours throughout his life, one which allowed him a completely free, unfettered approach to drawing, painting, photography, film and design. Jacobsen envisioned his architectural projects as pieces of total design where the boundaries between art, furniture design, the use of colours and architectural design were fluid. The House of the Future and the SAS Hotel in Copenhagen are particularly well-known examples.

Aalto's artistic talent was enormous, so much so that he could easily have become a leading Finnish visual artist. As a child, he received lessons in painting, drawing and watercolour, and he resumed those studies during his time as an architecture student. He also worked as an art critic and as an illustrator for magazines.

In his practice as a working architect, he became keenly interested in design, and taking his starting point in the completion of his first major work, the Paimio Sanatorium, he began experimenting with laminated and glued wood (glulam) as a material for furniture making. Some of his experiments turned out to have purely aesthetic potential only, and they became the starting point for a new mode of artistic expression for Aalto: reliefs. Bent curves, various approaches to gluing and split wood became abstract wall art in Aalto's hands. From the mid 1940s he also returned to painting, using colour and free forms as picture-building elements in an abstract idiom that harked back particularly to the Art Informel movement and American Expressionism.

Aalto took the free forms of experimentation and play with him into the realm of architecture, where he grew increasingly comfortable thinking in terms of free and fluid structures. This trait contributed to making him one of the most far-sighted architects of our time, one whose buildings soon became destinations for architecture and design students, including a certain young Danish furniture designer.

In the case of Juhl, Jacobsen and Aalto, artistic talent manifested itself as a creative urge in their formative youth, after which it was channelled in different directions. For all three, art would exert a significant influence on their endeavours throughout their professional lives.

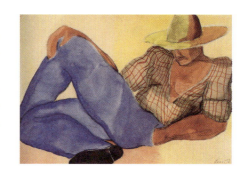

Early watercolour by Finn Juhl.

Watercolour by Arne Jacobsen.

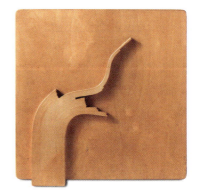

Relief of bent glulam by Alvar Aalto.

Peter Mathiesen Wegner.

This was not the case with Wegner, even though art played a significant role in his work for some time, and even though his story actually began like that of his three fellow designers: with a strong curiosity about art that was translated into an artistic practice.

The land of Wegner's youth

Wegner lived in Tønder from the time he was born in 1914 until he set out for North Zealand in 1935 at the age of twenty-one, having been drafted there for his compulsory military service. Tønder is located in a special region of Denmark where there is still a sizable German minority. In fact, Wegner was technically born in Germany, but despite their German ancestry, both his parents were very Danish-minded. They wore a Danish emblem pinned to their clothes and spoke Danish, specifically the Southern Jutland dialect, to their two children, Heini and Hans.

The Reunification which saw Southern Jutland once again reunited with Denmark after a public vote (the Schleswig plebiscites) coincided with Wegner beginning school, which meant that he only received a few months of instruction in German. After that, the school's official language was Danish. 'I was Danish and went to a Danish school, but I still played football with those who attended German school,' recalled Wegner about his early experience of the dual Danish-German culture.

The First World War broke out when Wegner was six months old, and his father, Peter Mathiesen Wegner, was later drafted into the German army. The time during and after the First World War was particularly hard for most people of Tønder, as many of the male members of their families had to go to war. Even if they were fortunate enough to come home again, they usually carried mental scars that were difficult for children to understand. However, Wegner's classmates and gymnastics teammates were lucky enough to benefit from the kindness and care of a young, newly transferred teacher, the aforementioned Marius Jacobsen. He not only taught Wegner to see; he also opened his home to his pupils, creating a safe space that could keep the aftermath of war at bay when a child needed it.

As a young man, Wegner attended gymnastics classes: first row, fourth from the right.

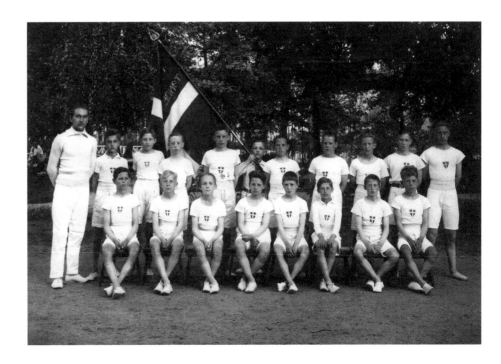

In addition to playing football and being on the gymnastics team, Wegner was a scout for a while, yet something very different exerted a particular pull on him in summer and winter alike: the waters of the Vidå river.

Meandering through Tønder from east to west, the Vidå was historically an important trade route for the town, which until the mid-sixteenth century had a harbour deep enough for large ships to dock. After that, increasing dyke construction meant that only ever smaller ships could sail into Tønder. A year before Wegner moved away, the small part of the harbour that still remained, known as The Ships' Bridge, was covered over.

Still, just beyond the outermost houses of the small town lay the waters of the Vidå and the flat, wide vistas of the Tønder Marsh with its distinctive flora and fauna and serene sense of tranquillity, all of which had an alluring effect on the young Wegner. In winter he could skate there, and in summer he could swim, sail or just lie down by the stream with some wood, building ships or carving figures.

Wegner on the Vidå river.

Tønder has a rich tradition for craftsmanship and applied art. Up through the eighteenth century, the flourishing lace production helped make the area prosperous, and the same period saw the objects produced by the many silversmiths in the area reach their acme, including the characteristic silver goblets and vinaigrettes – small containers holding a sponge soaked in fragrance. In the seventeenth century, Tønder was also home to one of Denmark's foremost woodcarving workshops, whose work can still be seen in Tønder's Christ Church.

The proud craft traditions were upheld over time, and in 1912 The Craftsmen's Association (Håndværkerforeningen) in Tønder was established. It quickly gained a membership of a hundred independent small businesses, a notable achievement for a town which was at the time home to approximately five thousand people. For example, there were no less than somewhere between fifteen and eighteen shoemakers in the town, recalled Wegner's father, who was a master shoemaker, co-founder of The Craftsmen's Association and later a member of the city council. His workshop was located at Smedegade 12, diagonally across from Christ Church in a white house that also served as the family home. Just a few steps from the Wegner home was the square, the absolute centre of the town. In an interview held on the occasion of a Wegner exhibition at Southern Jutland's art museum, Sønderjyllands Kunstmuseum, in 1979, the architect recalled how the streets in the vicinity of his childhood home boasted several workshops, including a painter and a wheelwright. In addition, a cabinetmaker by the name of H.F. Stahlberg had a small private workshop. People traded with each other, learnt from each other and looked after each other. Everyone contributed, and all were necessary components of the small community, making it run. The many workshops attracted children who were free to come and go as they pleased. Naturally, this also held true for Wegner and his older brother, letting them see first-hand how the craftsmen handled their tools, processed their materials and were diligent, focused and took the utmost care while working. But why did Wegner highlight experiences like these sixty years later?

Carvings in Tønder's Christ Church.

He did so to emphasise the influence these Tønder craftsmen had on his subsequent working life. He knew that their work ethic and the community spirit that prevailed in the workshops had been important building blocks of the professional ethos and set of rules he would later apply in his own life's work. Having grown up in a milieu of a distinctly artisan nature, witnessing the creation of everyday objects at close quarters and sensing the attitude taken by his father and other craftsmen towards being professional creators had a profound impact on him. Those formative experiences remained embedded in him when he left his birthplace behind.

Wegner's father, an apprentice and journeyman in the family's shoemaking workshop.

At a very young age, Wegner became adept at woodcarving, using knives from his father's workshop for the purpose. The results included toy boats that he launched on the Vidå as a child. Later he would build homemade kayaks large enough for him to sail in.

Given his evident talent for working with wood and his keen curiosity about the craftsmanship on display in the workshops, there was no doubt: Wegner would become a craftsman rather than pursue an academic career. So when he had completed his compulsory seven years of schooling in 1928, he was apprenticed to Stahlberg the cabinetmaker at the age of fourteen. Around this time, he also made his first forays into the realm of art – or, more precisely, his first attempts at working with different artistic media. This was probably no coincidence.

This picture was presumably taken on the day Wegner became a fully trained cabinetmaker. He receives an affectionate punch from a fellow professional, a mark of respect for his great skill.

The first works

Apprenticing as a carpenter involved more than practical work in the master's workshop. During winter, apprentices also received instruction at the local technical school, which in Tønder was run by the Craftsmen's Association. During their first two years, the students were taught Danish, geometry, freehand drawing and orthographic projection drawing, while the last two years were spent learning correspondence, arithmetic, bookkeeping and professional drawing.

It is hardly surprising that students had to learn technical drawing, but in fact freehand drawing was accorded equal importance on the certificate Wegner received upon completing his apprenticeship in 1932. He received the top grade, 'exceptionally good' ('ug'), in all drawing subjects, while he 'only' received the second-best grade, 'very good' ('mg'), in the rest.

It seems likely that Wegner's excellent grades in drawing of all kinds reflected the fact that he had discovered a skill set he could link to his ability to see. Here, one may reasonably speculate, he had found a discipline that interested him. Whatever the case may be, his apprenticeship years from 1928 to 1932 certainly saw the emergence of an interest in art or artistic design that manifested itself in several ways: Wegner began to take an active interest in exhibitions of art and applied art at the Tønder Museum, and also began trying out different artistic media.

Two prints from 1929 are among the earliest known surviving works from Wegner's hand. One depicts an iconic Tønder motif from the square, showing the town's oldest house and famous linden tree in the centre of the scene with the tower of Christ Church in the background; the other shows a farmhouse reminiscent of Wegner's paternal grandparents' place in the village of Rørkær, a few kilometres outside Tønder. Being views of buildings, these pieces might well have been responses to a task set by the technical school, where students had to practice perspective drawing. If the results proved good, they might be transferred to an etching. And for a fifteen-year-old cabinetmaker's apprentice, those etchings certainly merit a 'well done' even if they still evince a certain awkwardness in line, shading and the rendering of trees and foliage.

Two undated paintings presumably also date from this period, as the signature is similar to that on the two etchings. One of them is also a street view from Tønder, and in many ways it is more interesting than the etching of the square; the painting reproduces Wegner's childhood street and home. Here, the creator was able to express himself in colour, and that fact alone meant that he could imbue the image with greater feeling and atmosphere. The decision to let the street extend across the entire width of the canvas leads the viewer into the picture, where the row of houses on one side and the green of the trees on the other evoke a protective, pleasant air. All the houses appear in a soft terracotta that almost seems to give way before Wegner's childhood home, standing out prominently with its white walls. The door is a calm, soothing green, and several windows are open, creating the impression that this is a safe home where everyone is welcome.

The second painting is a portrait of an unknown child. The composition is classically conventional, the sitter facing the light. The forms are built up by a tonal use of delicate fields of colour, but the hair stands out by being rendered with coarse brushstrokes and a thicker layer of paint that points in a more expressive direction.

This venture into the art of painting may have been spurred on by an exhibition Wegner saw at the German school in Tønder in 1930, showing works by the Danish-German artist Emil Nolde, one of the leading

Etching of the square in Tønder and Wegner's grandparents' house in Rørkær.

Oil painting of Wegner's childhood home in Smedegade.

Portrait of an unknown girl.

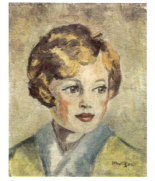

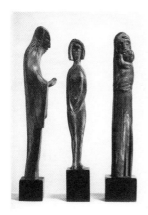

Three wooden figures *Prophet*, *Girl with Lowered Arms* and *Mother and Child*, carved by the artist Emil Nolde, all from 1913.

Expressionists of the day. Hailing from the village of Nolde, not far from Tønder, the artist was considered a local and maintained very close ties to the area throughout his adult life.

Wegner appreciated Nolde's rendering of the marsh and its colours, which he recognised from his own first-hand experience of spectacles such as sunsets over the Tønder Marsh. The two men also shared another common interest: woodcarving. While Wegner did not explicitly cite Nolde as a source of inspiration for his own carved pieces, it seems obvious that his familiarity with Nolde's work also included an awareness and perhaps even an admiration of him as a craftsman. Because as it happens, Nolde trained as a woodcarver in Flensburg in 1888 and had worked in this capacity for a few years before he went on to become a teacher at the Industrial and Commercial Museum (Industrie- und Gewerbemuseum, now the Textile Museum) in St. Gallen. Nolde would occasionally make direct use of his training as a woodcarver in his artistic endeavours; for example, the 1910s saw him carve human figures for a while. Poised somewhere between fine sculpture and applied art, these pieces might have been lifted straight out of his painted world.

Wegner's woodcarvings also occupy this borderland between sculpture and handicraft, or art and craft. Here he could combine his woodworking skills with his newfound interest in fine art. He was familiar with the carvings in Tønder's Christ Church and perhaps also with Nolde's essays in the craft, but inspiration for the subject matter of his own works came from, among other things, exploring the galleries at Tønder Museum, which opened in 1923. The museum's collection was eclectic and wide-ranging. It contained fine art, primarily from the Kunstnergaven til Sønderjylland,[2] but also a large collection of the best and most characteristic applied arts from West Schleswig in the form of furniture, tiles, silver and lace, among others. Both collections gave him ideas that he translated into design and art pieces during his career. In 1950, he designed the Flag Halyard Chair, inspired by the shape of a special mud shovel used in the marshes, having seen such an implement exhibited at the Tønder Museum. And during his apprenticeship he was so captivated by a porcelain figure called *Wave and Rock* from The Royal Copenhagen Porcelain Manufactory (Den Kongelige Porcelainsfabrik) that he chose to carve it in wood.

Created in 1892, the *Wave and Rock* sculpture juxtaposes many opposites in terms of theme and composition alike: the free and the bound, the calm and the restless, man and woman. It is a symbolic and sensuous subject imbued with artistic and aesthetic power that clearly fascinated the young carpenter's apprentice. Even so, his desire to paraphrase the piece in wood presumably rested more than anything on a wish to challenge himself, flexing his abilities and proving that he was indeed capable of carving such a detailed and precise composition in wood.

An old oak log that he had found at a demolition site was unearthed for the purpose, and the creative process was documented in photographs. The identity of the photographer is not known, but it was probably either himself or a close family member, as the photos were neatly placed in the family album.

Wegner carved several such wooden figures.[3] The inspirations for the other pieces are not known. Unlike *Wave and Rock*, they may be amalgamations of art he has seen rather than outright copies, imbuing them with greater artistic independence.

There can be no doubt that growing up in Tønder played a pivotal role in Wegner's life, influencing his later work as a furniture designer. Significant aspects of his professional ethos were founded there through social

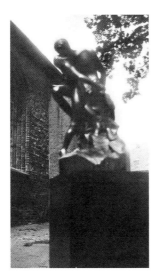

The making of the sculpture *Wave and Rock* was documented in photographs. The Tønder church square can be seen in the background.

Figure of a woman, carved in wood by Wegner.

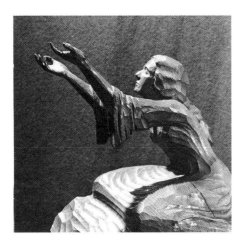

interaction, schooling and the spirit permeating the local workshops, and like Juhl, Jacobsen and Aalto, Wegner's teenage years saw him become an active practitioner of art – and the art of seeing. Unlike his fellow designers, however, Wegner never considered making art his livelihood. Not even when he enrolled at The School of Decorative Art in Copenhagen and was told that his artistic talent could well make him a portrait painter.

The School of Decorative Art

In the 1950s, The New York Times once quoted Wegner as having said: 'If I hadn't worked with sculpture, I probably never would have designed chairs.' With this statement, Wegner reaffirmed the importance of having become acquainted with fine art at an early age and the impact it had on his furniture design; he had not been content with joinery work alone.

Even so, it should be said that, generally speaking, Wegner highlighted his professional training as a joiner and cabinetmaker over fine art when asked to explain his success as a furniture designer. Talking about how his furniture designs came about and how he made decisions about shapes and lines, he rarely, if ever, referred to his artistic sense or aesthetic motivations. He always pointed to the fact that he thought like a cabinetmaker and made the decisions a cabinetmaker would have made. In doing so, he always grounded his designs in common sense and professional logic. Artistic furniture design, he believed, was an unfortunate trend.

Even so, in 1936 he decided – after three years as a journeyman working for Stahlberg, half a year in military service and a three-month course at the Technological Institute (Teknologisk Institut) in Copenhagen – to apply for the furniture programme at The School of Decorative Art in Copenhagen, thereby opting for an artistic education.

The School of Decorative Art was established in 1930 with the ambition of strengthening the Danish education offerings within the field of decorative and applied art, presenting a curriculum aimed directly at specific professions. The school offered five programmes, of which the furniture programme was one. Here the goal was to train cabinetmakers to run their own business, meaning that prospective students must hold a journeyman's certificate to enrol. Graduates from the programme would also qualify to work as furniture designers at design studios.

The school was housed in the former Frederiks Hospital in Bredgade, which had been transformed into the Danish Museum of Decorative Art (Kunstindustrimuseet, now Designmuseum Danmark) in 1923 after a thorough refurbishment. Thus, the museum's collection of historical furniture was readily available for teaching purposes, forging a natural connection to the past designs on whose shoulders the students' own works would stand.

Instruction at the school was carried out by architects and artists, and in addition to disciplines such as measuring furniture and accounting, the school's pre-eminent task was teaching the students to draw. As at the technical schools the students had attended during their apprentice days, they were taught geometry and projection drawing, they had to learn to draw furniture and interior layouts and elevations, and finally they were also taught freehand drawing and watercolour. Good drawing skills would be an invaluable tool for students upon graduating: it would stand them in good stead in the preparation of design competition submissions when giving loose ideas a more definite shape, and not least in the preparation of working drawings.

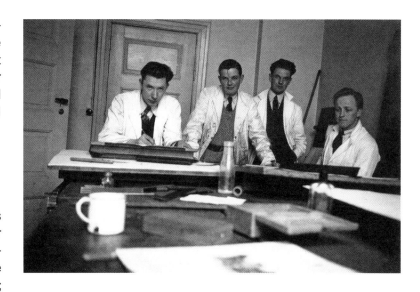

Wegner, Børge Mogensen, and two fellow students from The School of Decorative Art in Copenhagen.

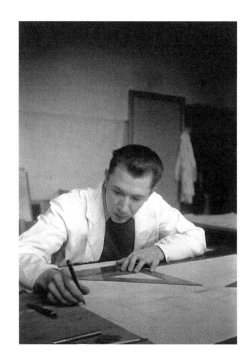

Wegner as a young student at The School of Decorative Art.

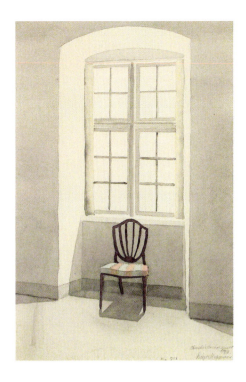 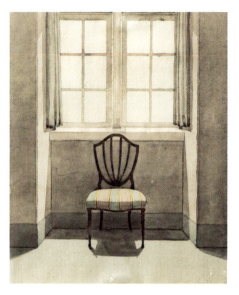

At The School of Decorative Art, students were tasked with drawing historical furniture from the collection of the Danish Museum of Decorative Art. To the left is Børge Mogensen's watercolour of a Hepplewhite chair and to the right is Wegner's.

Børge Mogensen and Wegner formed a lifelong friendship at The School of Decorative Art. Here, Wegner has portrayed his friend.

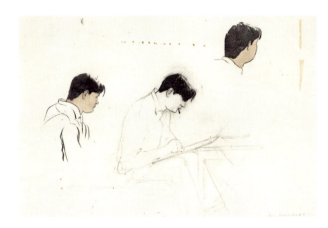

Wegner's time at the school would prove to be short: after his second year there, he accepted an offer to work at Erik Møller and Arne Jacobsen's design studio in Aarhus, working on the new City Hall there. Even so, he gained invaluable skills at the school. As he later stated: 'I learned many useful things such as technical drawing and design basics.'[4]

He originally intended to complete his education at the school in 1943, when there was no longer a contract keeping him in Aarhus, but the war made it difficult to return to Copenhagen. When he finally did return to The School of Decorative Art in 1946, he did so as a teacher.

Wegner saved a number of drawings and watercolours from his student days. Presumably far from all of them, but a sizable quantity. Given that they were school assignments – set tasks with specific parameters – one can hardly claim that they reflect a desire for artistic expression on Wegner's part. Nevertheless, his personality and artistic sensibility comes clearly to the fore in some of the drawings.

The students were tasked with doing life drawing classes in the croquis manner, meaning that the resulting sketches were by their very nature rapidly executed exercises. Wegner's drawings in this category clearly reflect this: they lack interest and nerve. It is plain to see that the rendering of the human form did not inspire much effort in him.

The sense of completing a set assignment is also clearly evident in his projection drawings of furniture and in his renderings of furnished rooms, the perspective painstakingly correct. Here, the most important thing was to capture the correct dimensions, angles, plans and perspectives, not to display artistic nerve. Wegner was highly adept at these disciplines, yet there was little to distinguish his drawings from those of his peers.

This also held true when the students were tasked with painting watercolours of furniture in various styles from the Danish Museum of Decorative Art, as can be seen when comparing two drawings of an English Hepplewhite chair made by Wegner and his good friend and fellow student Børge Mogensen. And yet: Wegner's drawing has greater nuance. The walls have more texture and tactility, his lighting displays greater variation, even though the light outside is reproduced in the same neutral way, and finally the chair emerges before us with greater realism. It comes across as crisper, firmer, more dynamic and conveys a sense of greater volume in the seat. Finally, the cover is not just hinted at, as in Mogensen's watercolour; here its surface comes to life with vivid clarity.

Such close reading of Wegner's watercolours emphasises his painterly skills, his sense of colour, his mastery of painting with watercolour – a difficult discipline – and his keen powers of perception. The same applies to a similar watercolour of a Louis Seize sofa, where the slightly shiny surface of the cover in particular is reproduced with eminent skill. Wegner kept both watercolours framed, which suggests that they were on display at some point and, by extension, that he himself appreciated their artistic value.

The years at The School of Decorative Art not only gave Wegner the technical and artistic skills he needed to apply for employment at a design studio or to work as an independent furniture designer; he also found a lifelong friend in Børge Mogensen. A drawing from the school testifies to this relationship.

The drawing depicts a young, deeply concentrated Mogensen bent over a watercolour at his drawing board, brush in hand. His signature features, a cigarette dangling from his mouth and his dark hair with an unruly lock at the front, are the only aspects to be coloured in. The rest of the body is only faintly indicated with a pencil. On the left side of the full-length portrait, Mogensen is seen in half-length, still with his eyes directed to his own drawing, while on the right side he is shown with his head completely turned away.

The piece works well as a portrait, partly because the individual characteristics make the sitter easily recognisable, but also because Wegner chose to portray Mogensen at a moment of keen, focused concentration where he closed in on himself. It seems as if Mogensen was unaware of being studied and drawn in the moment, suggesting that Wegner had obtained Mogensen's consent to act as a model in advance. They trust each other because they are friends.

Indeed, Wegner gave the portrait to Mogensen as a gesture of friendship. Much later, it came back to Wegner accompanied by a loving greeting from Mogensen's wife, Alice, on Wegner's birthday on 2 April 1976, a posthumous gift from his friend who had died four years earlier.

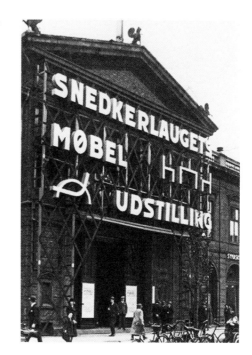

The annual Cabinetmakers' Guild Exhibitions in Copenhagen would play a major role in shaping Wegner's innovative approach to furniture.

Design competitions

Artistic ability was certainly needed in the cabinetmaking trade. In the period after the First World War, Danish cabinetmakers became hard pressed by the sale of imported furniture, which was cheaper than the furniture the craftsmen could produce in their workshops. The masters knew that something needed to change if they were to get their businesses back on an even keel. They had to think radically differently in terms of design.

Out of this need grew first the School of Furniture at the Royal Danish Academy of Fine Arts (Kunstakademiets Møbelskole). A few years later the furniture programme at The School of Decorative Art arrived. The two schools aimed to produce young graduates who could draw and invent new things, think fresh thoughts.

A third initiative was the creation of The Cabinetmakers' Guild Exhibitions (Snedkerlaugsudstillingerne) in 1927, which, according to the statutes from 1930, aimed 'to maintain and promote the interest in and sale of good, tasteful furniture of excellent artisanal manufacture and to support the direct connection between the productive craftsman and the public.'[5] The statutes were changed slightly in 1952; for example, the term 'tasteful' was replaced by 'artistic'. The guild exhibitions were, then, sales exhibitions where the guild strove to reinvent handcrafted furniture while promoting good taste.

Beginning in 1933, a design competition was announced before each exhibition, inviting furniture designers to submit proposals for new furniture. Those who successfully cleared the jury's hurdle would then team up with a master cabinetmaker who would produce the piece in question.

Wegner first exhibited at The Cabinetmakers' Guild Exhibition in 1938, presenting an armchair and a suite of dining room furniture made by master cabinetmaker Ove Lander. This was presumably the first time that Wegner submitted coloured drawings to a competition, but it was far from the last: he went on to take part in every one of these guild exhibitions from 1941 until the concept was discontinued in 1966. Throughout the years, he collaborated with his own master cabinetmaker, Johannes Hansen; the only exception being 1945 and 1946, when he and Mogensen jointly designed the stands for Mogensen's master cabinetmaker, I. Christiansen, as well as for Johannes Hansen. The successful collaboration between Wegner and Hansen resulted

Master carpenter Ove Lander's stand at The Cabinetmakers' Guild Exhibition in 1938, featuring dining room furniture and an armchair designed by Wegner.

The catalogue for a competition for modern, low-cost furniture issued by the Museum of Modern Art in New York in 1948. Wegner submitted several furniture designs.

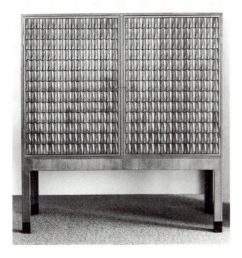

The Crocodile Cabinet was designed in 1950. It testifies to Wegner's interest in keeping the art of woodcarving alive.

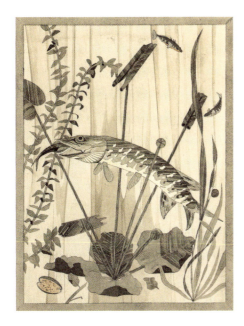

Coloured sketch for one door of the Fish Cabinet.

in several iconic chair designs, such as the Peacock Chair and the Round Chair. The sketches and drawings submitted for these exhibitions typically consisted of a proposal for the stand layout and design and projection drawings of the furniture to be featured there.

During the 1940s, Wegner also participated in other competitions that required him to put his design and furniture proposals on paper in an illustrative, technically and artistically satisfactory way. If these proposals were awarded, reaching either first, second or third place in the competition, this yielded a cash prize that made a not insignificant contribution to the household finances.

He participated and won awards in an eclectic range of competitions, including the following: a souvenir design competition calling for a Copenhagen spoon, the Danish Petroleum Company (DDPA)'s design competition for a new service station, the competition held by The National Association of Danish Arts and Crafts and Industrial Design (Landsforeningen for Dansk Kunsthåndværk og Kunstindustri) for design proposals suitable for production intended for domestic settings, the Aarhus Tourist Association's design competition inviting proposals for a medal, emblem or suchlike to commemorate the 500th jubilee of the city, and a silverware design competition on the occasion of the 100th anniversary of the jeweller A. Michelsen, official purveyor to the Royal Danish Court and maker of orders.

In 1948, Wegner also participated in an international competition issued by the Museum of Modern Art in New York. Officially called the International Competition for Low-Cost Furniture Design, it arose out of the post-war period's desire to spread out 'the good life' to as many people as possible. Small houses and small flats had become a common form of housing in the USA and Denmark alike, and these new types of accommodation called for furniture that was adapted to modern production methods, was relatively cheap and did not take up too much space.

The competition was divided into two furniture groups: seating units and storage units. Wegner submitted coloured designs for both categories, presenting four different chair designs. All four were adapted for industrial production, and one of them was stackable. In the storage category, his cabinet had a built-in desk function. Wegner was not awarded a prize and these furniture designs did not enter production, but nevertheless the competition saw his designs being introduced in the United States for the first time.

A final important competition in which Wegner participated was issued by the Danish guild of woodcarvers. He submitted a proposal for a cabinet and a coffee table, which won him second place. Importantly, the competition gave him a renewed veneration for the art of woodcarving, making him eager to secure it a place among the modern furniture designs.

In an undated interview believed to be from 1940, Wegner criticised his generation for having a taste for 'Renaissance furniture' with pasted-on carvings. To his mind, modern furniture should be practical, look beautiful and be neither too expensive nor too big. 'But shouldn't modern furniture also possess an artistic element?' asked the journalist. 'Of course it should, but it won't be in the form of sham woodcarving work. It will be simpler, cleaner,' explained Wegner. 'It goes without saying that [woodcarving] must be done by an artist to become art.' In 1944, he set out to make his words a reality, thus also acting as an artist himself.

For Johannes Hansen's stand at The Cabinetmakers' Guild Exhibition, he created a cabinet that, when closed, appeared to be a very simple design with two doors. When opened, however, it revealed an impressive array of figurative wood inlay on the back of the doors and across a row of drawers placed above a pull-out desktop. When open, the piece looked like a triptych.

The intarsia work was not just a repetitive pattern of the kind featured in other Wegner cabinets sporting carved and inlaid work from 1946 and 1950 respectively, where the patterns pointed back to his exercises in wallpaper design at The School of Decorative Art. In the 1944 cabinet, he went all in on the artistic approach, virtually painting with veneers.

The figurative subject matter originated from his serene childhood days on the banks of the Vidå river in Tønder, where he had studied the wildlife in the stream. In preparation for working on the actual cabinet, he drew the intarsia design in pencil and then coloured in the figural parts in watercolour. Given that these designs were Wegner's most important working tool when cutting out the 3,000 individual veneer pieces that make up the final image, the watercolours appear as a strange hybrid between a schematic working drawing and a beautiful, subtly toned painting in its own right.

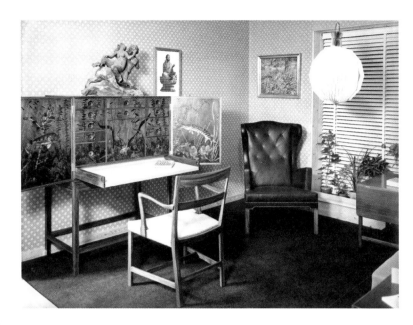

Most of the critics reviewing Johannes Hansen's stand at the 1944 exhibition were deeply impressed by the nature and quality of the cabinet, and Wegner was personally pleased with it. He knew very well that he had performed a major feat of craftsmanship and artistry alike. Few cabinetmakers would have been able to match this endeavour, and the feat continued to amuse him thirty years later, when he stated: 'Oh, well, making a cabinet like that, which is so difficult to do, is of course madly effortful and reactionary, but on the other hand it is no worse than taking up painting.'[6] Yet painted he had – in wood and watercolour. Indeed, Wegner would subsequently use the (often greatly enlarged) designs for the cabinet, which later came to be known as the Fish Cabinet, as backdrops or wall art in other contexts where his furniture was exhibited.

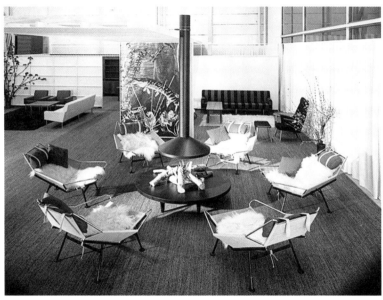

When following the artistic trail in Wegner's career, it is noteworthy that whereas peers such as Finn Juhl exhibited his furniture interacting with the works of other artists, Wegner opted to use his own watercolours on several occasions. Did he consider his portrait of the Buddha or the views from the marshes around Tønder – works presented on the walls of Johannes Hansen's stand at The Cabinetmakers' Guild Exhibition in 1941 and 1944 respectively – as art? Or were they just the easiest option for putting 'something on the wall', merely what happened to be at hand when adding the final touches to the stand? The latter seems unlikely. We may reasonably assume that Wegner was very much aware of the details of display. After all, he had been taught the discipline in school. One may conclude, then, that the watercolours were there in their own right – as artistic manifestations.

Examples of Wegner using his watercolours as wall decoration include Johannes Hansen's stand at The Cabinetmakers' Guild Exhibition in 1944, where Wegner presented his Fish Cabinet, and Johannes Hansen's major Wegner exhibition at his own workshop in 1965.

Art influenced Wegner most strongly in the 1940s. In the 1950s, art only sporadically found its way into Wegner's design and exhibition processes, as his professional craftsmanship ethos became the all-dominant force behind his endeavours.

'We may have several master cabinetmakers who are as skilled [as Wegner], but we have no furniture designer who outdoes him in modern design,'[7] wrote fellow furniture designer and architect Kaare Klint in 1953, a legendary teacher at the Royal Danish Academy of Fine Arts, although Wegner never got to experience his teaching. The quote speaks volumes about Wegner's skills as a craftsman, but it also proclaims his ability to do quite extraordinary things as a furniture designer. Surely this had more than a little to do with his special ability to see – and with his artistic talent?

Notes

1. Kirsten Risgaard, 'Her lærte han håndværket og hentede inspiration' [Here he learned his craft and found inspiration], Berlingske, May 1979.
2. Literally 'The Artists' Gift to Southern Jutland', a collection of some five hundred works donated as a gift celebrating the Reunification in which Southern Jutland rejoined Denmark in 1920.
3. The following examples are known: an Ad Astra in the form of a woman reaching for the stars, an eagle, a boxer and a despairing figure, as well as a number of bowls devoid of decoration.
4. Fine Woodworking, 3 April 1980.
5. Poul Christiansen, *Fyrretyve år med Snedkerlaugets Møbeludstillinger* [Forty years of The Cabinetmakers' Guild Exhibitions], Gads Forlag 1986.
6. Henrik Sten Møller, 'Det skal ikke gøres svært' [It shouldn't be made difficult], Politiken, 31 April 1978.
7. Kaare Klint in a letter to Bent Svendsen, 13 March 1953.

Historic furniture

The watercolours of furniture from the Danish Museum of Decorative Art were done while Wegner was a student at The School of Decorative Art. Most are carefully finished, testifying to their having been created at a school where a correct and precise rendering of scale, perspective and shading was of paramount importance. Such assignments also made students familiar with furniture designs from earlier eras. Wegner kept several of these watercolours framed, which suggests that he himself was pleased with them and wanted to preserve them for posterity.

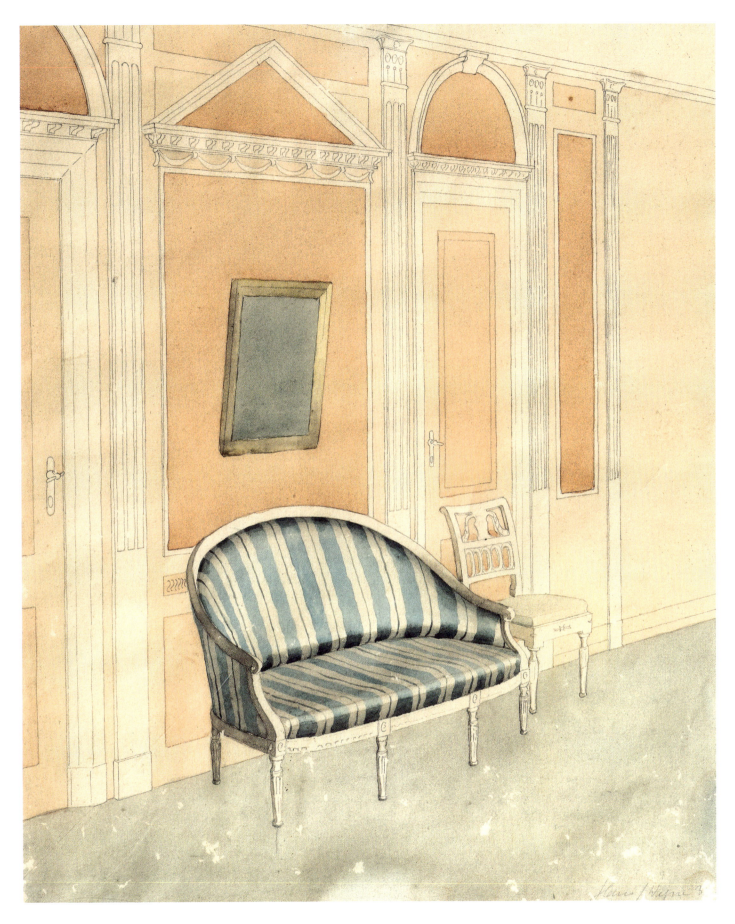

Louis Seize sofa
Perspective view
Watercolour
1930s

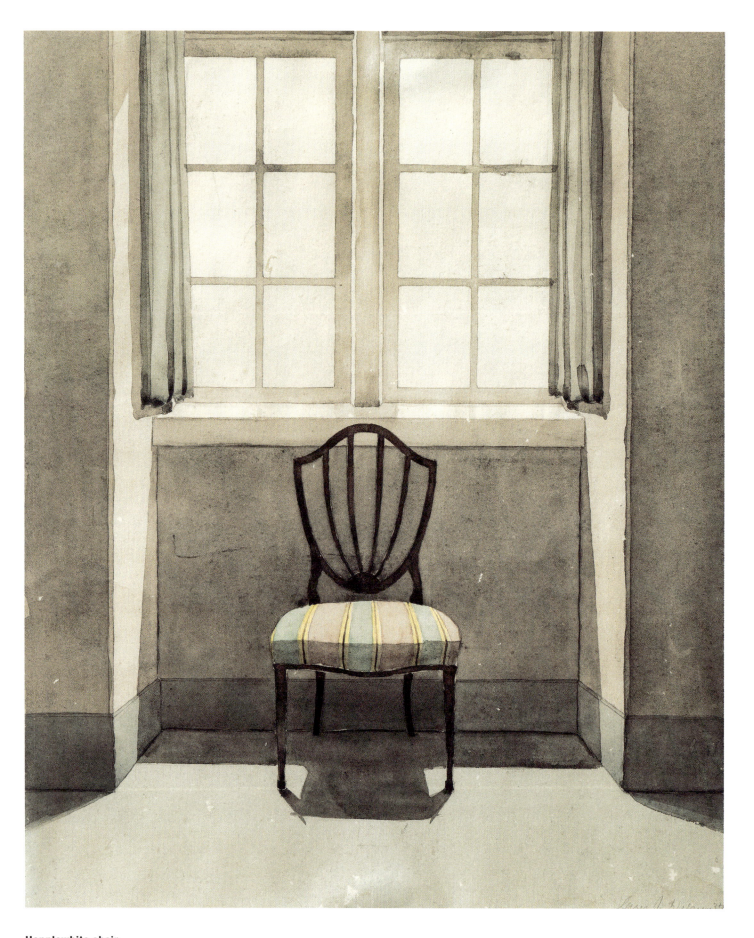

Hepplewhite chair
Perspective view
Watercolour
1930s

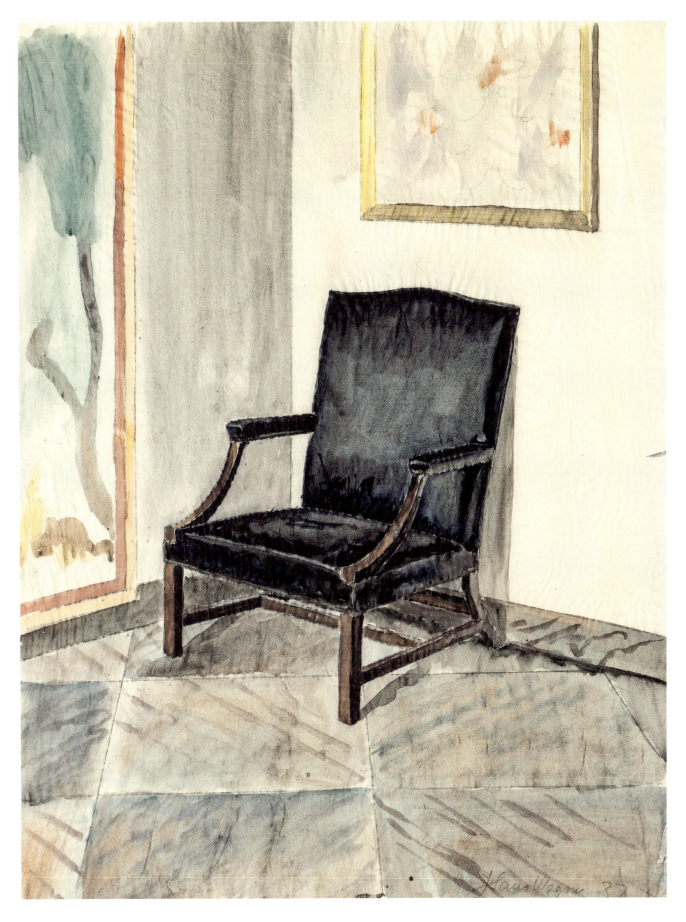

Armchair by Ole Wanscher
Perspective view
Watercolour
1937

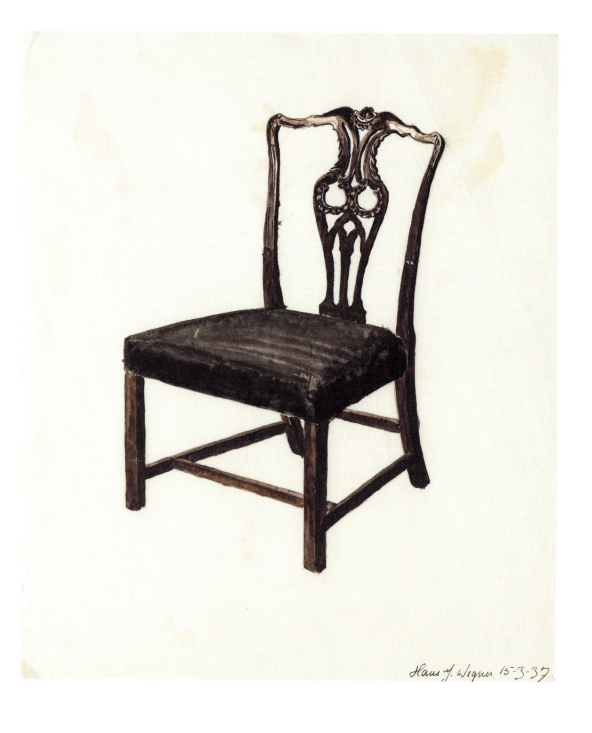

Chippendale chair
Perspective view
Watercolour
1937

Rococo chair with the monogram of Christian IV
Perspective view
Watercolour
Undated

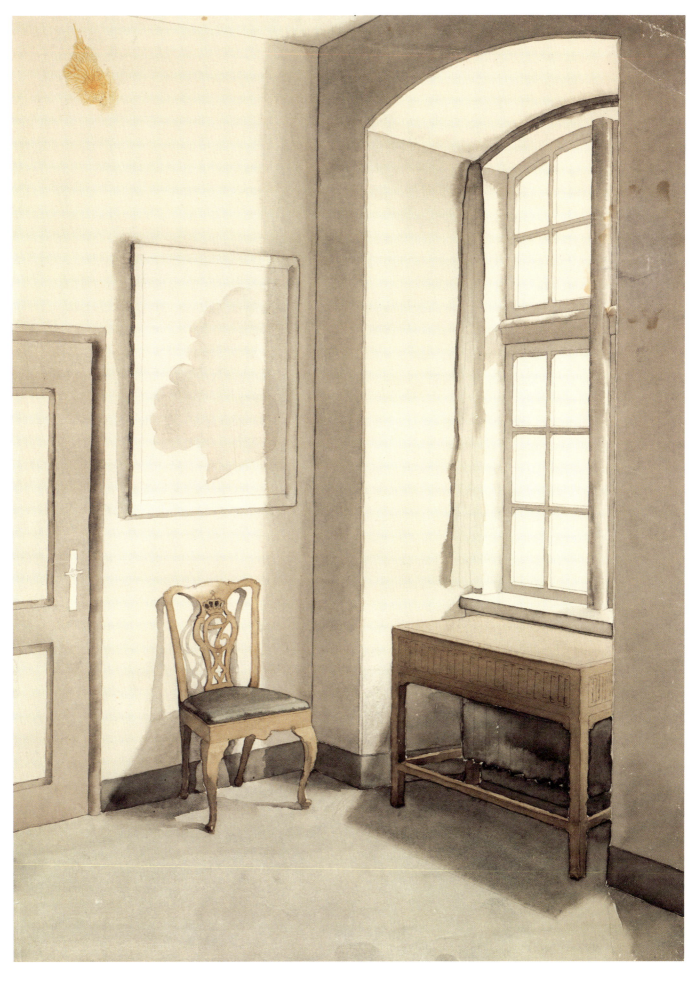

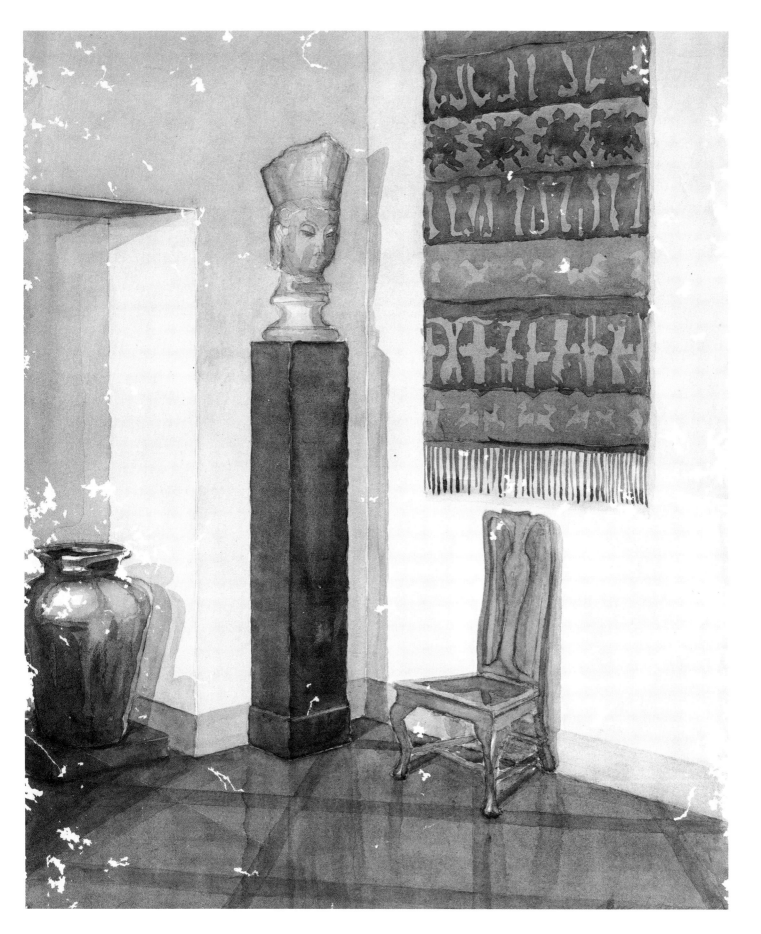

English Queen Anne chair
Perspective view
Watercolour
Undated

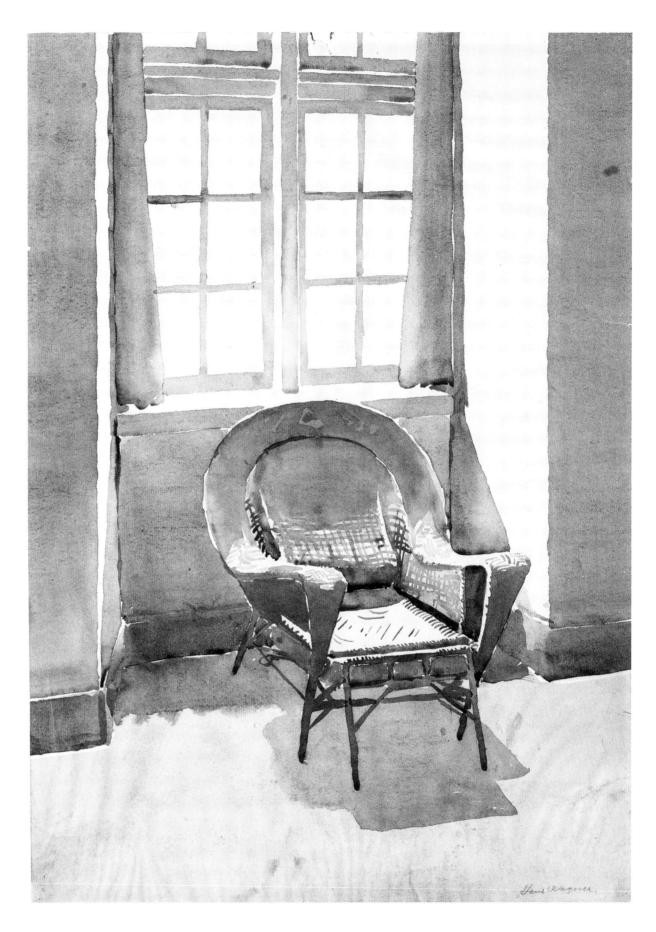

Chinese wicker chair
Perspective view
Watercolour
Undated

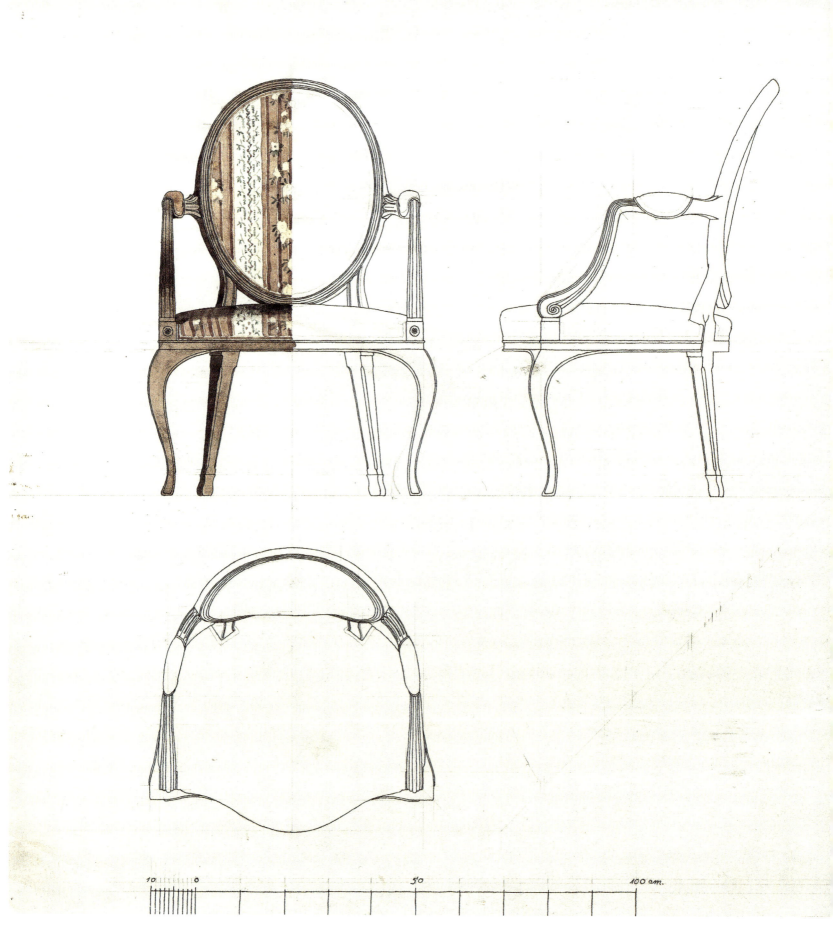

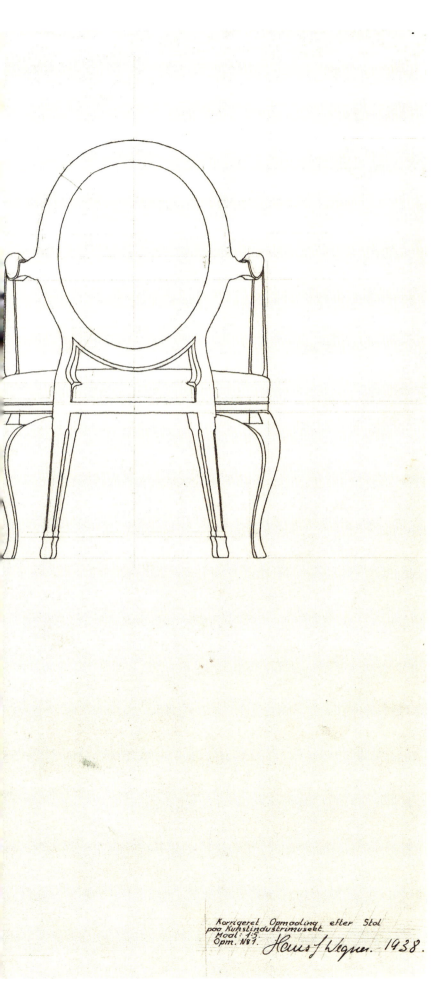

Chair (corrected measurement)
Plan and elevation
Pencil, pen and watercolour
1938

Furniture

In these drawings, which primarily consist of studies from The School of Decorative Art and submissions for design competitions, the most important aspects are the measurements and technical details. Here the use of watercolours is not meant to create a mood or be expressive. Rather, the colours are included to accurately represent Wegner's choice of wood or textile or to emphasise a particular detail of the furniture. One of the more interesting aspects of these drawings, which were created in the early 1930s and 1940s, is that even by this point we find a Wegner who not only is fond of furniture with beautiful wooden surfaces but also likes to give them striking colours.

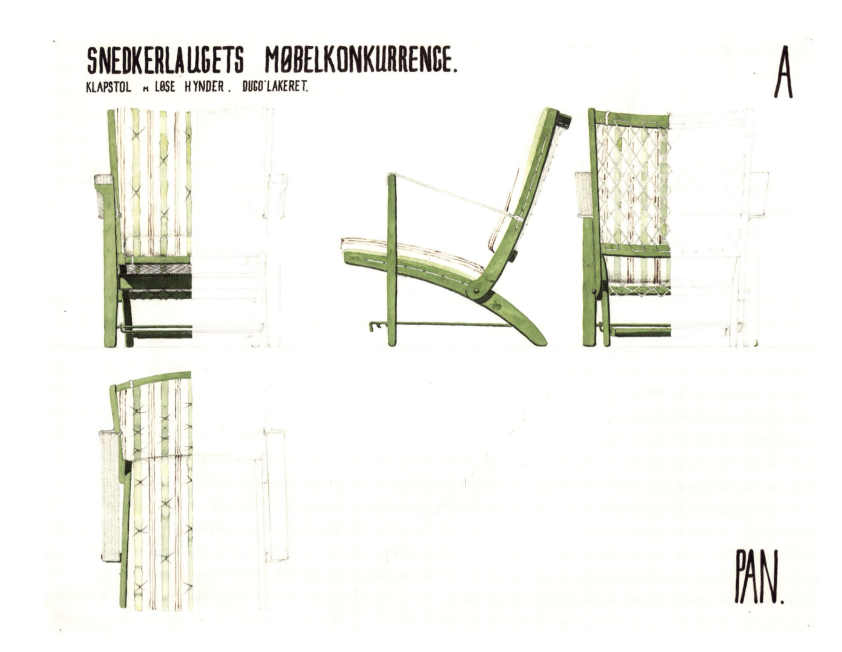

Folding chair with loose cushions, submission for The Cabinetmakers' Guild furniture design competition
Plan and elevations
Pencil and watercolour
Undated

Konkurrence om Forslag til Møbler
Sofa, Stol og Bord. 15
Møblerne udføres af Asketræ.

Forfra

Fra Siden

Plan

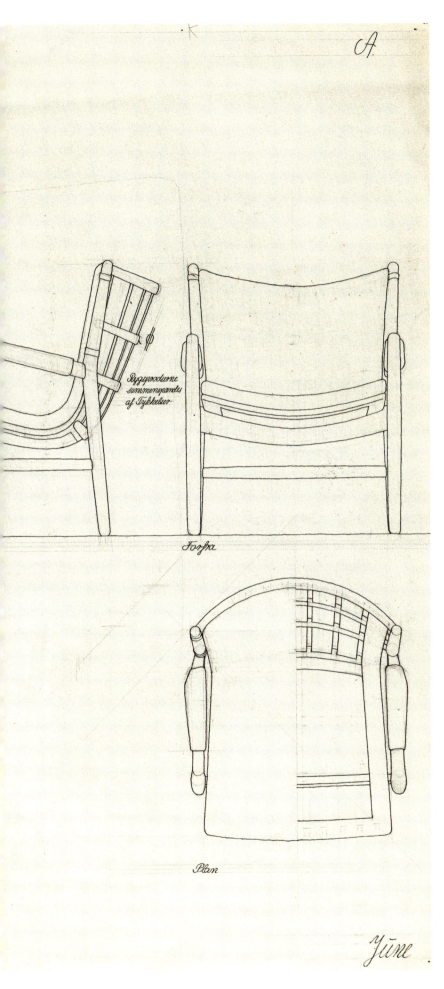

Sofa, chair and table, submission for design competition
Plans and elevations
Pencil, pen and watercolour
Undated

Sofa med løse Hynder.

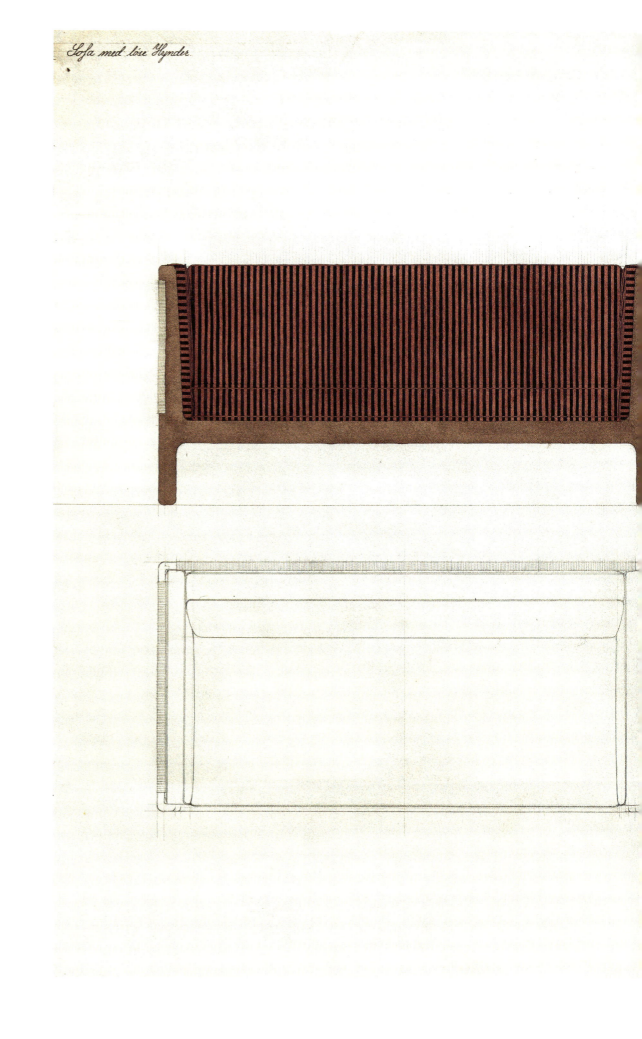

Sofa med løse Hynder.

Sofa with loose seat cushions
Plan and elevations
Pencil and watercolour
Undated

Living room, work desk
Section and elevations
Pencil, pen and watercolour
Undated

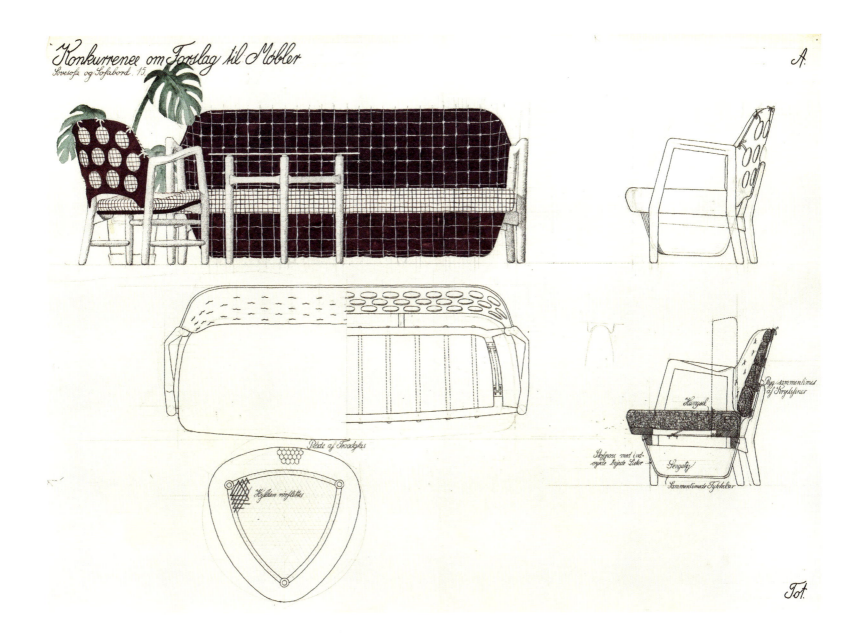

**Sofa bed and coffee table,
submission for design competition**
Plan, section and elevations
Pencil, pen and watercolour
Undated

Bed, bedside table and dressing table, submission for design competition
Plans and elevations
Pencil, pen and watercolour
Undated

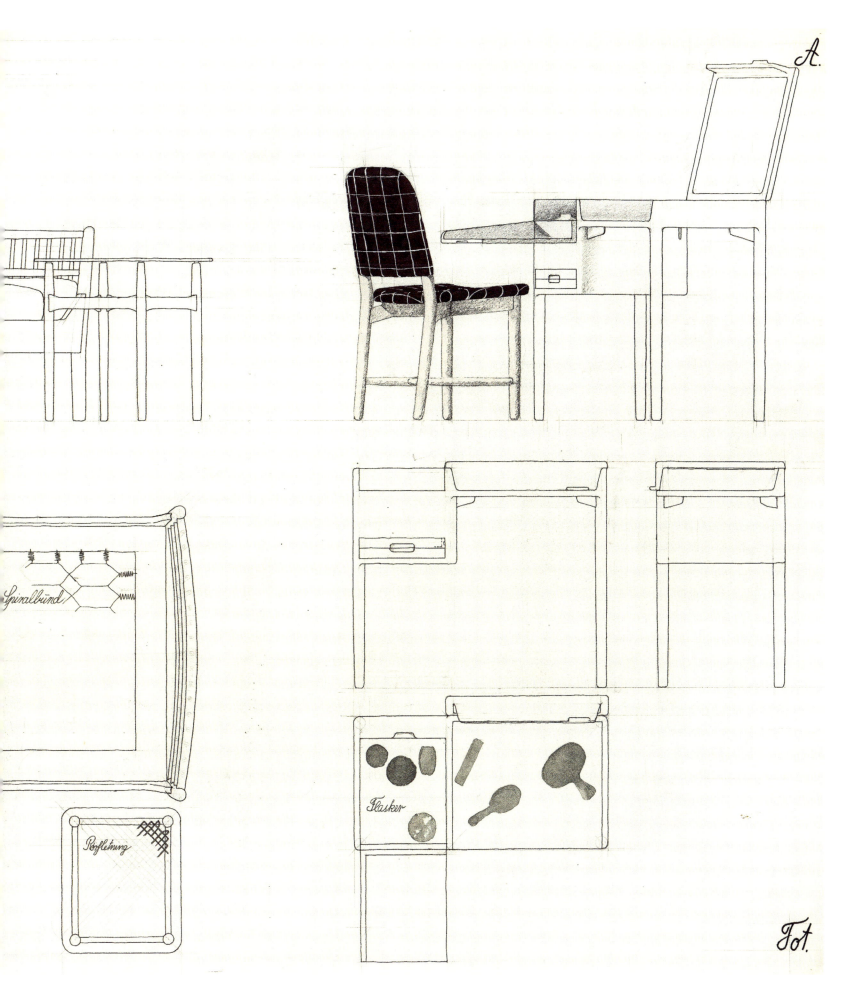

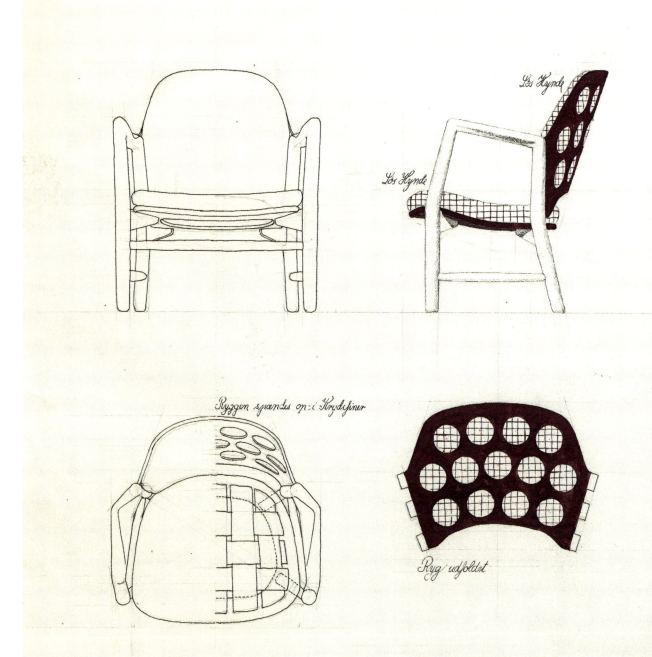

**Armchair and recliner,
submission for design competition**
Plans and elevations
Pencil, pen and watercolour
Undated

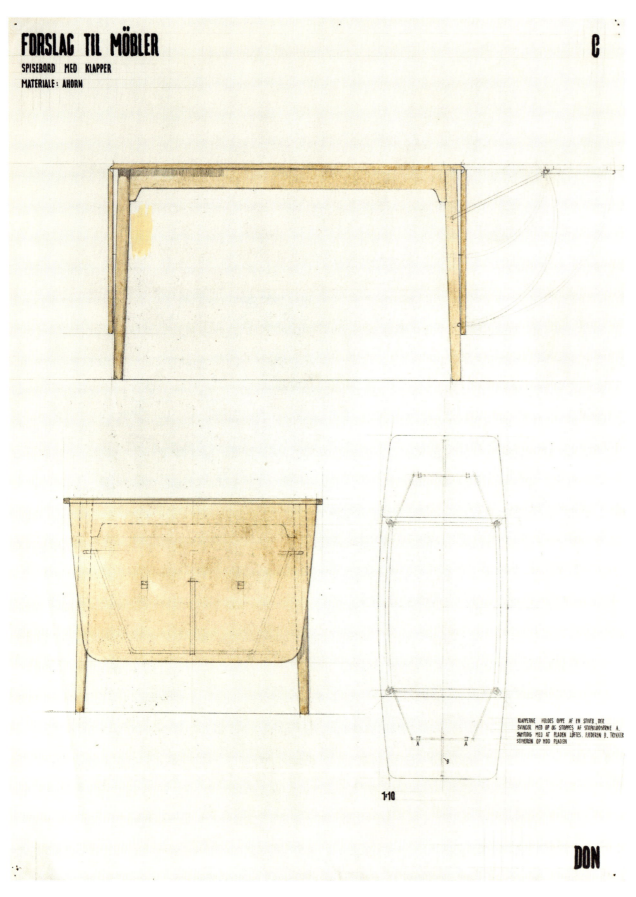

Drop-leaf dining table
Plan and elevations
Pencil, pen and watercolour
Undated

Dining chair
Plan and elevations
Pencil, pen and watercolour
Undated

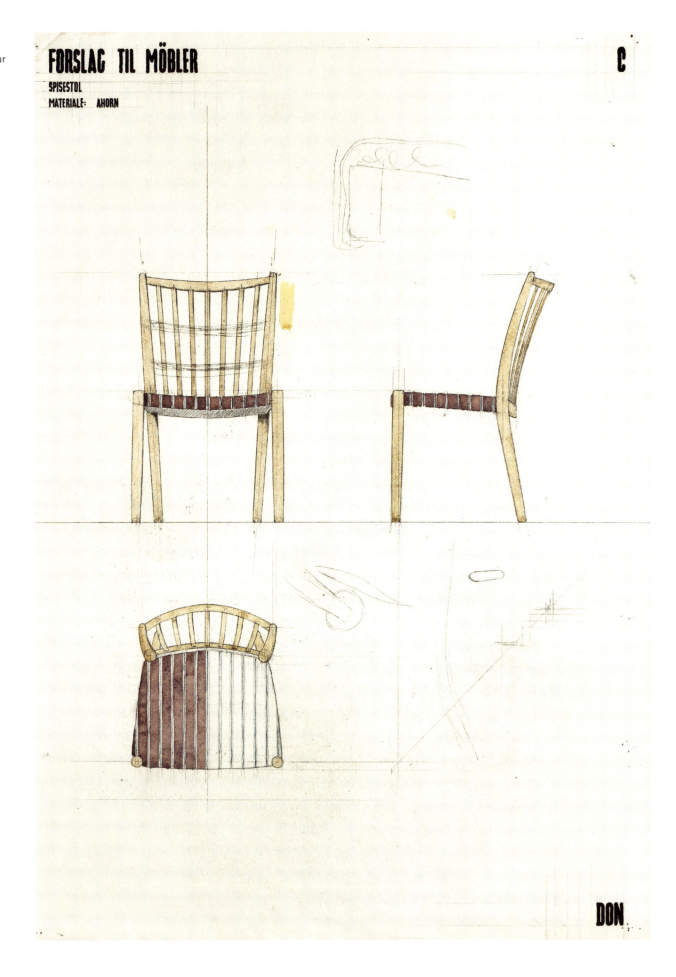

MÖBLER TIL EN OPHOLDSSTUE
SKRIVEBORD OG STOL
MATERIALE: TEAK

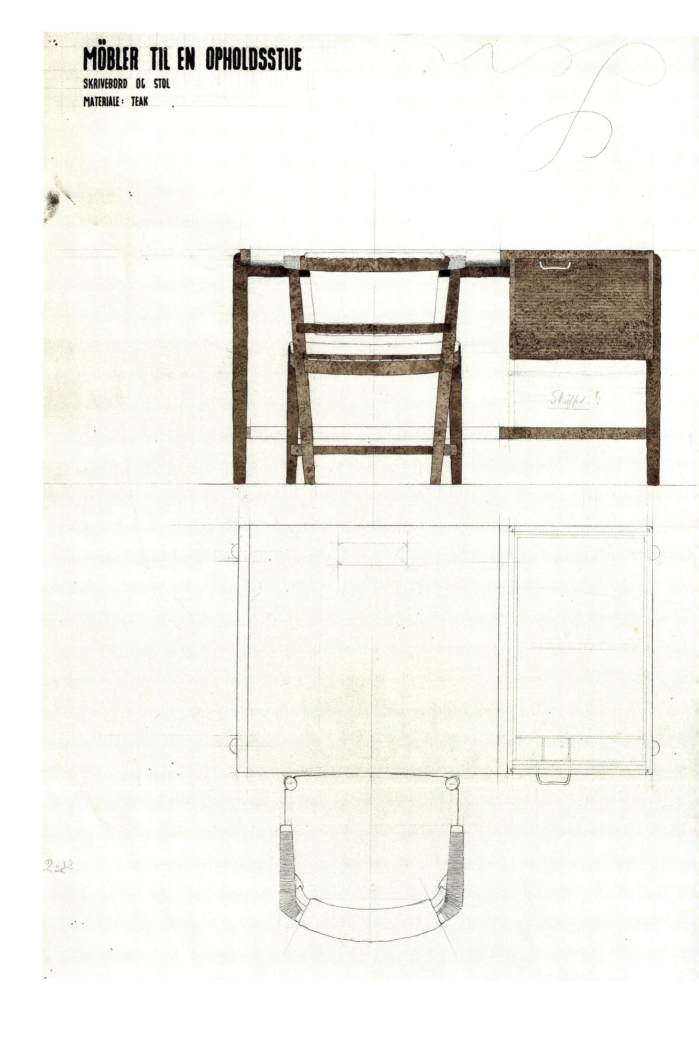

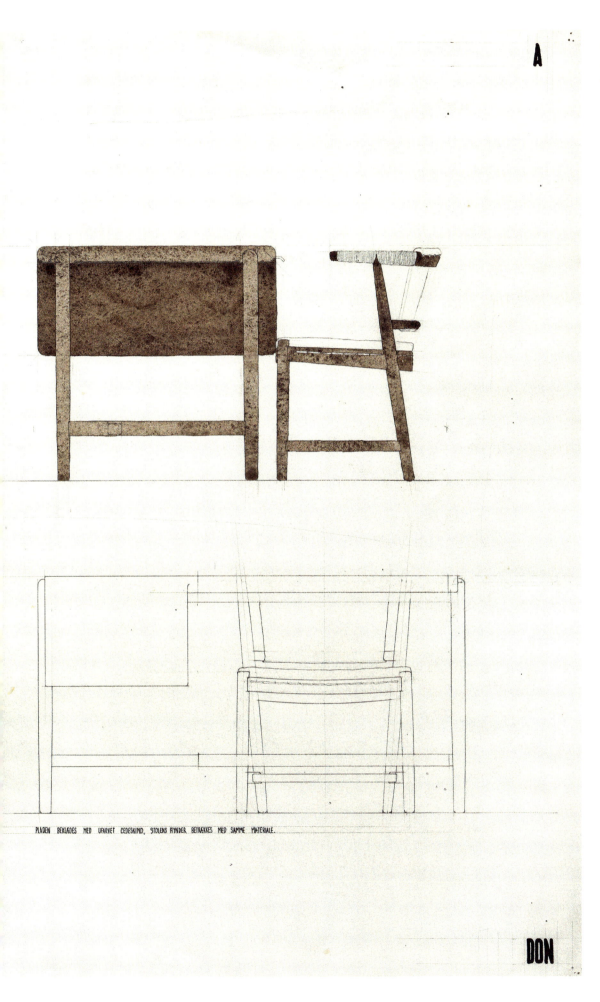

Living room furniture, desk and chair
Plan and elevations
Pencil, pen and watercolour
Undated

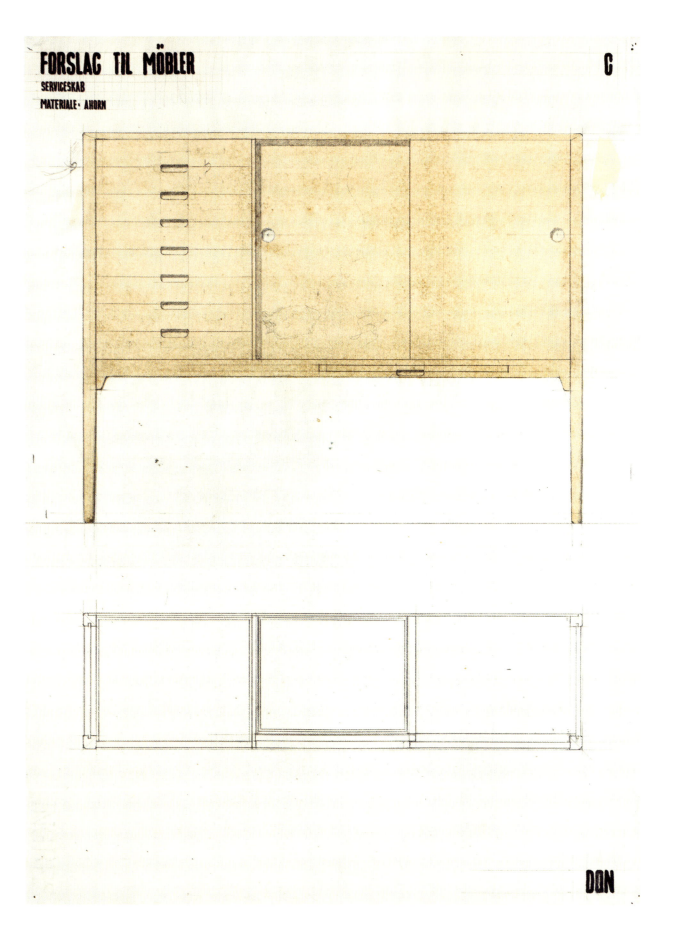

China cabinet
Plan and elevation
Pencil, pen and watercolour
Undated

Wing chair
Plan and elevations
Pencil, pen and watercolour
Undated

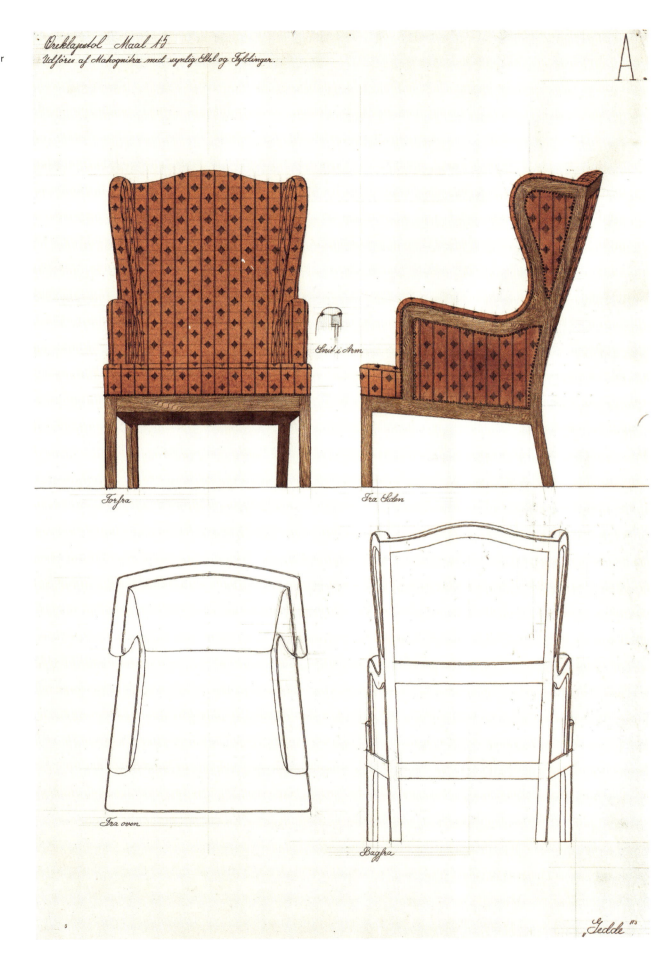

Chair
Plan and elevations
Pen and watercolour
1937

Armchair
Plans and elevations
Pencil, pen and watercolour
Undated

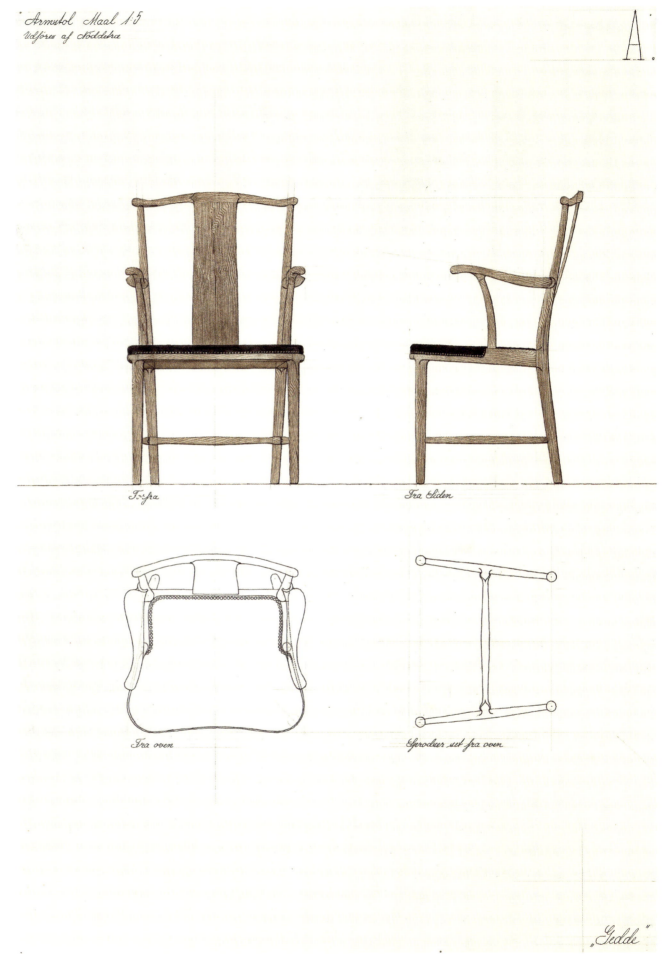

Armchair
Plan and elevations
Pen and watercolour
1937

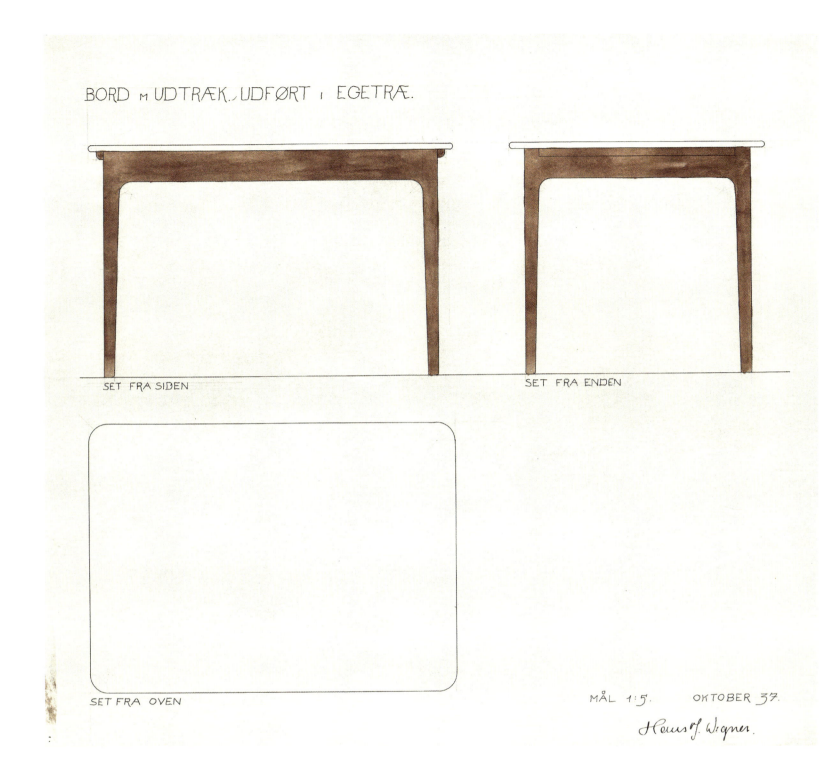

Table, extendable
Plan and elevations
Pen and watercolour
1937

Sideboard with tambour doors and six drawers
Elevations, perspective view and detail
Pen and watercolour
1937

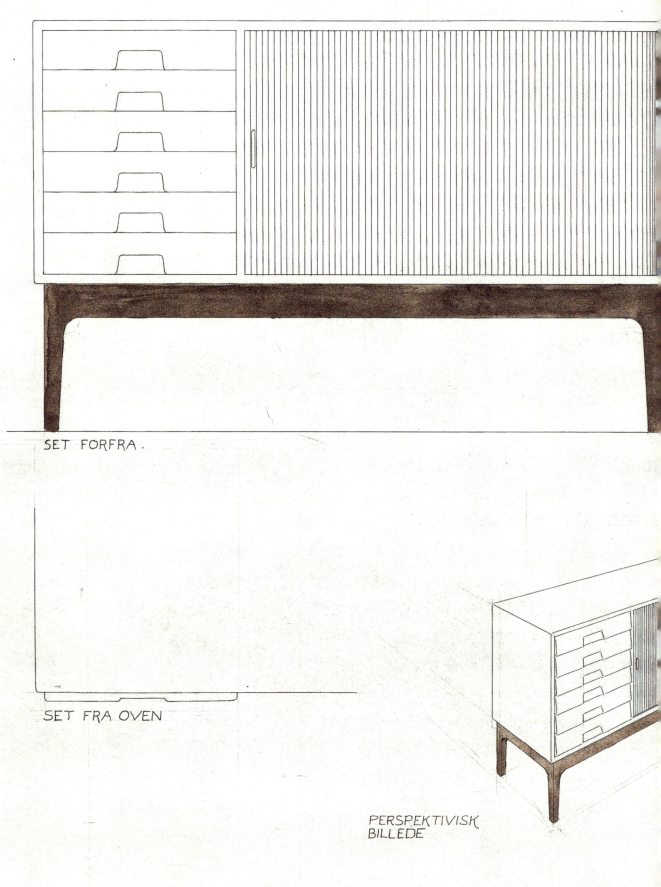

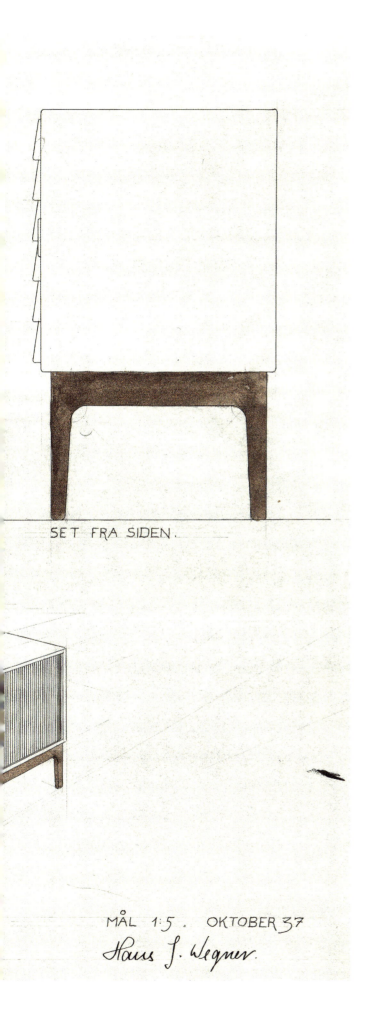

SET FRA SIDEN.

MÅL 1:5 . OKTOBER 37
Hans J. Wegner.

Living room. Rest area
Plan and elevation
Pencil, pen and watercolour
Undated

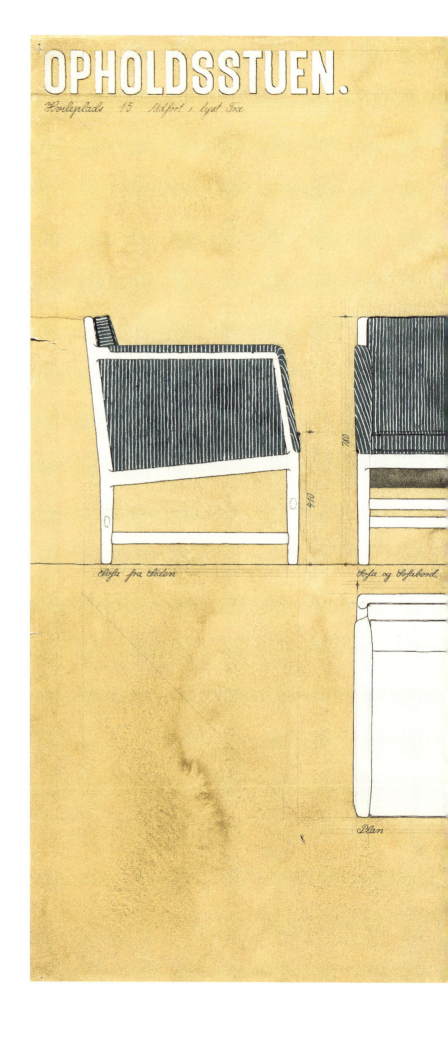

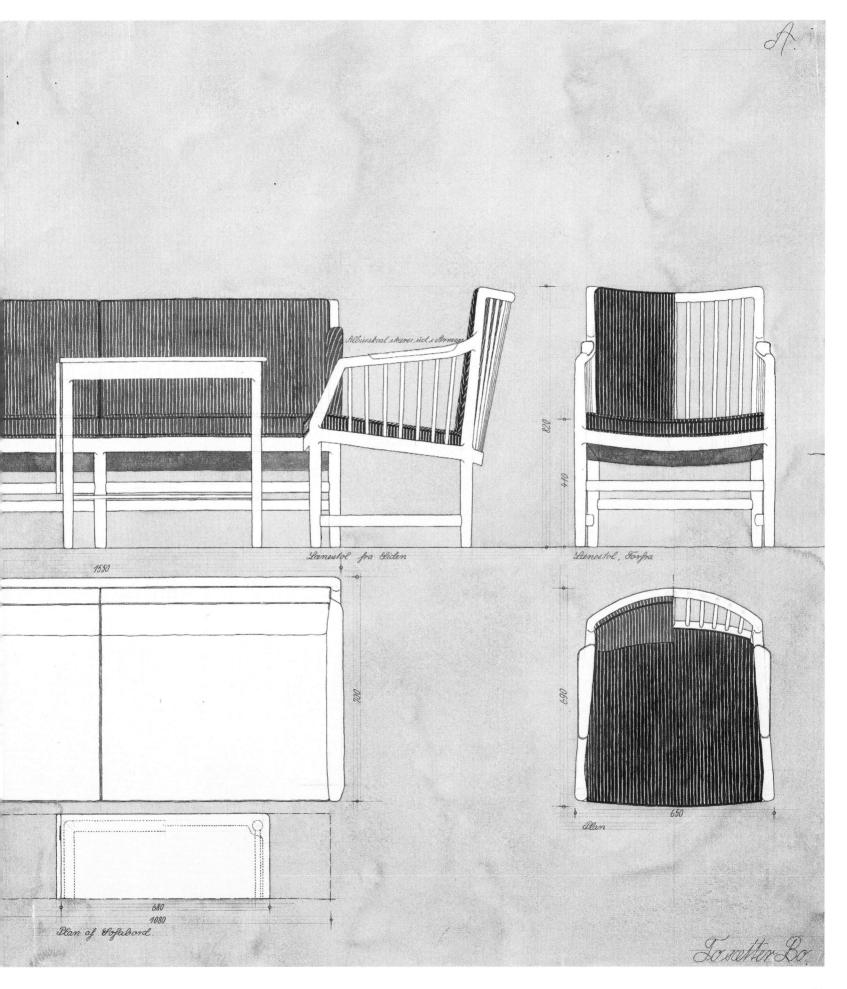

Living room. Workspace
Floor plan and elevations
Pencil, pen and watercolour
Undated

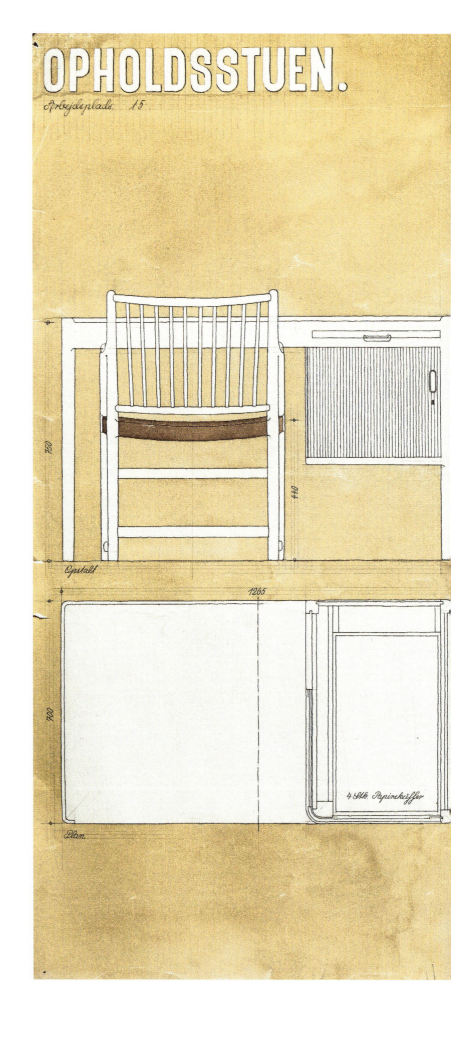

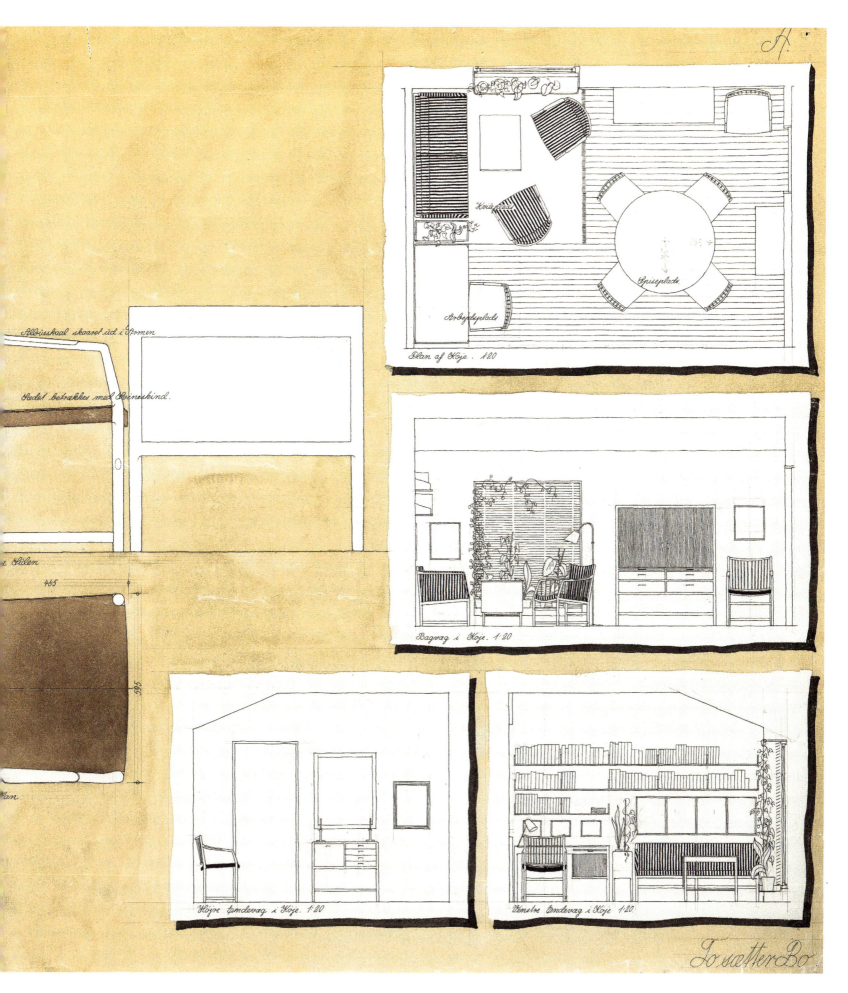

Living room. Dining area
Plans and elevations
Pencil, pen and watercolour
Undated

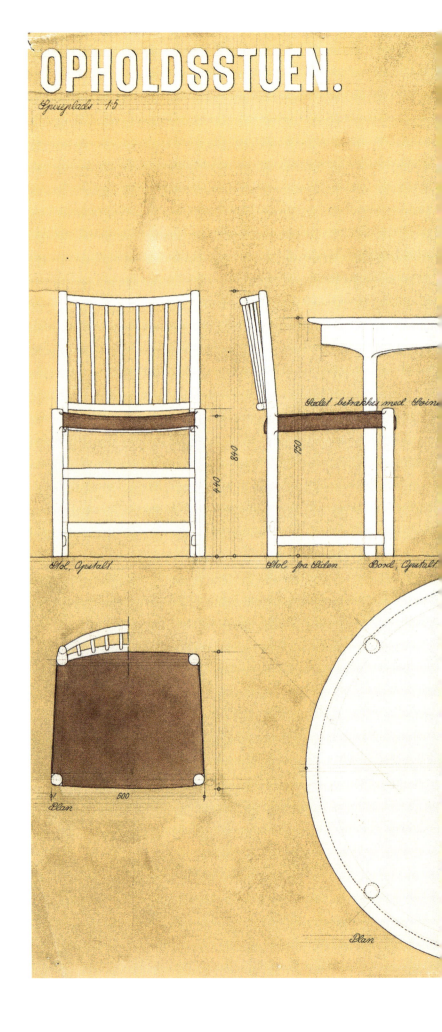

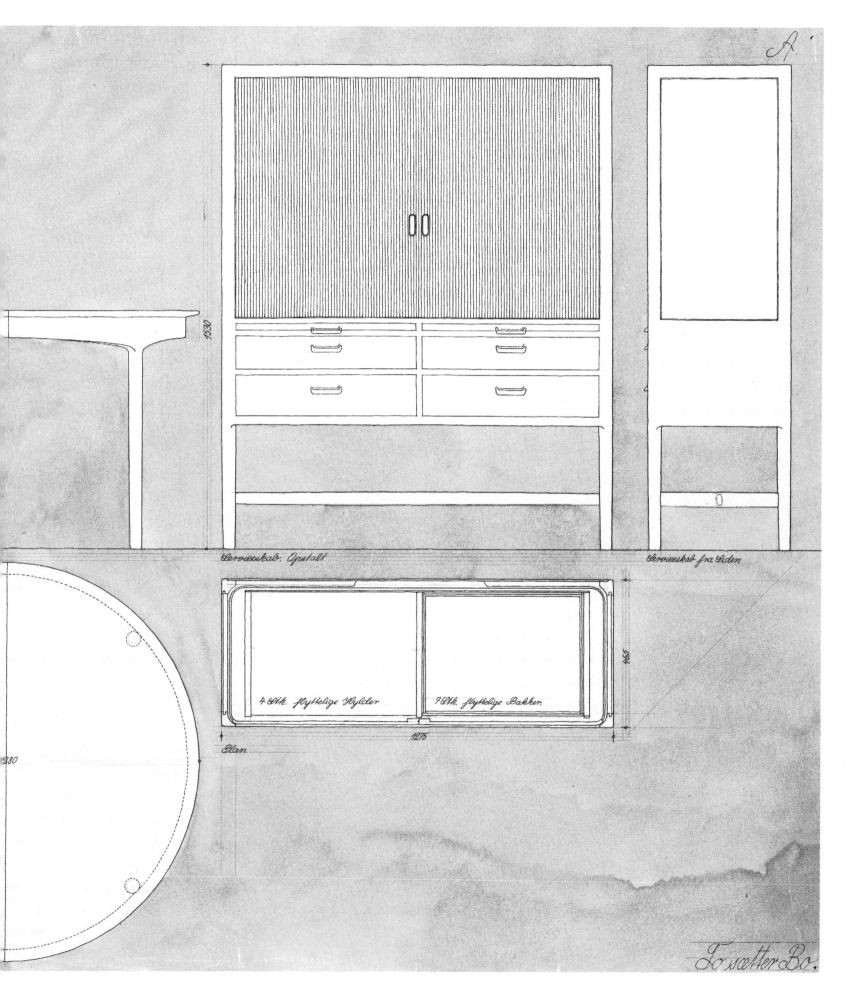

Private office. Desk and armchair
Plans, section and elevations
Pencil, pen and watercolour
Undated

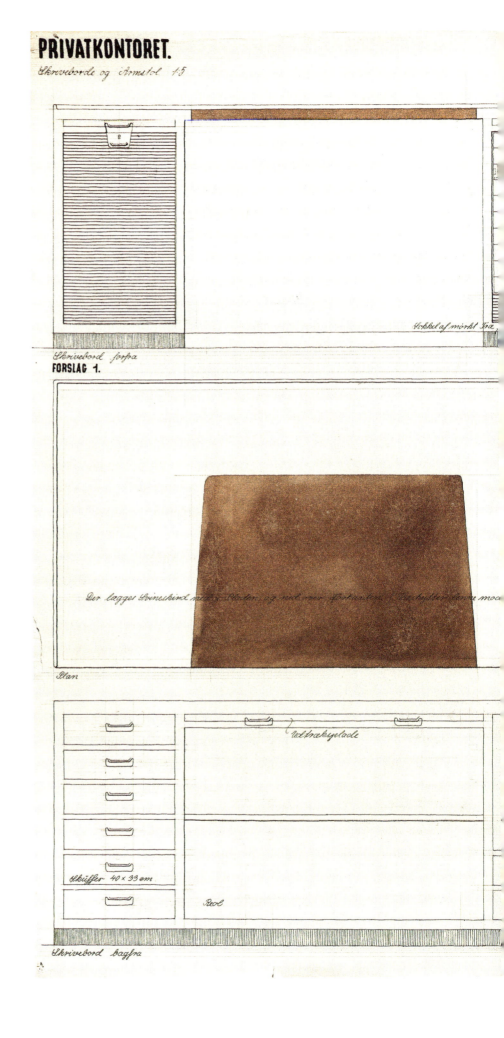

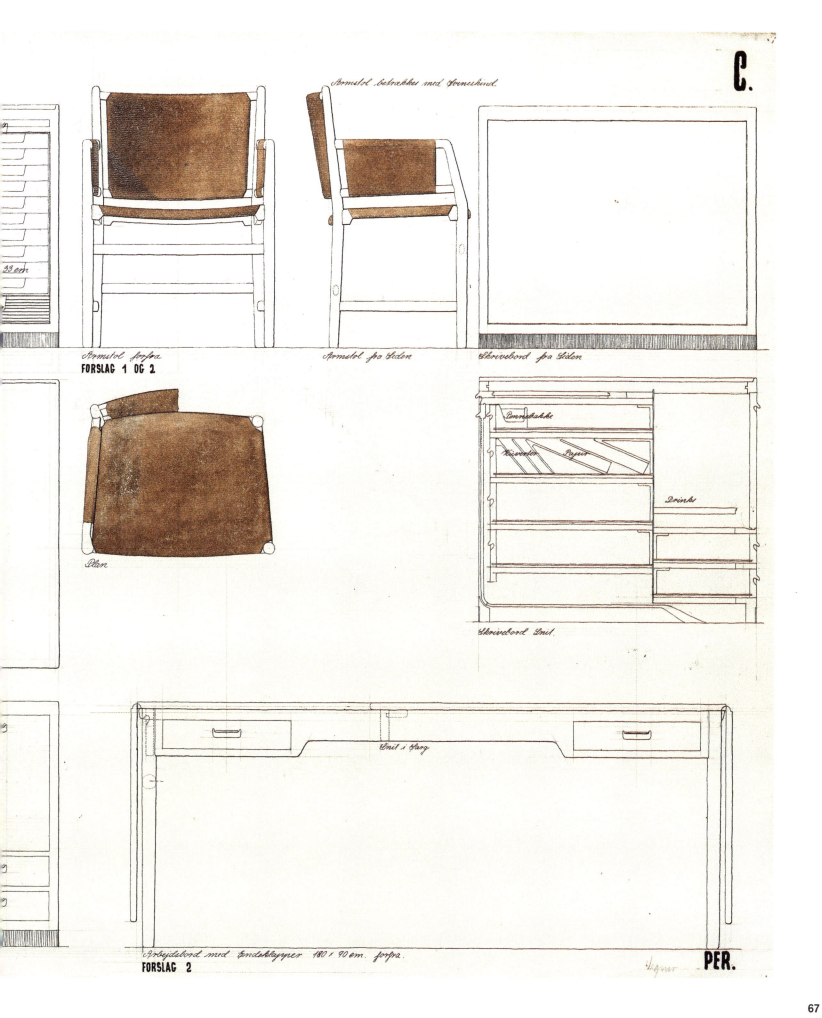

Sewing table
Section and elevations
Pencil, pen and watercolour
Undated

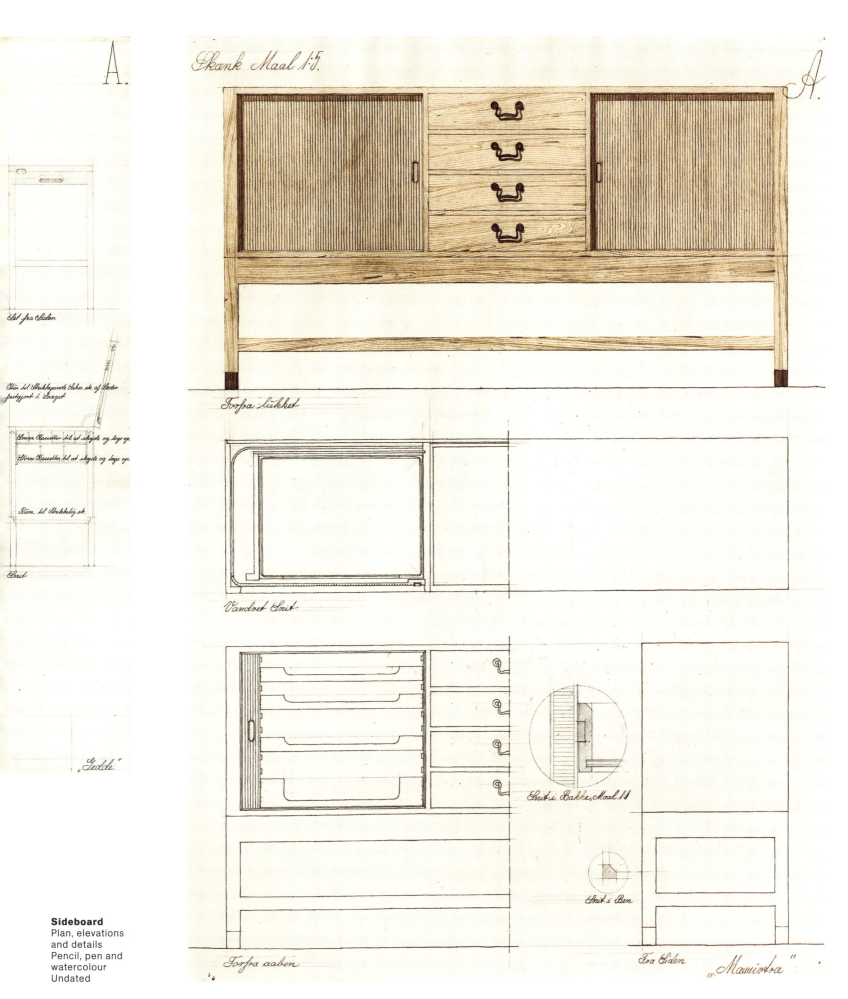

Sideboard
Plan, elevations and details
Pencil, pen and watercolour
Undated

Wardrobe, submission for design competition
Plan, elevations and details
Pencil, pen and watercolour
Undated

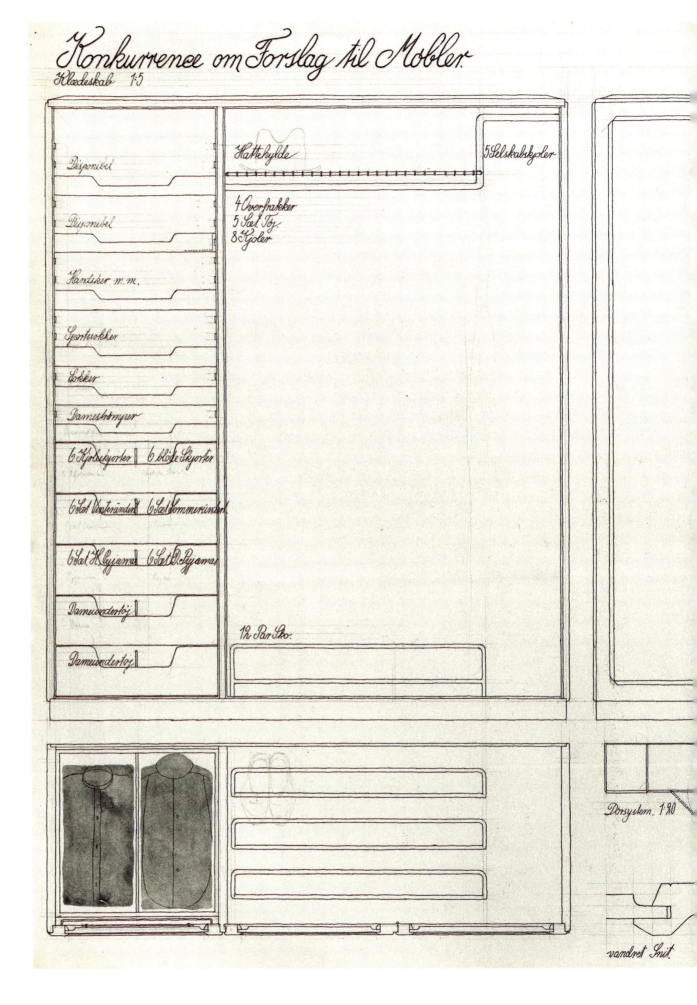

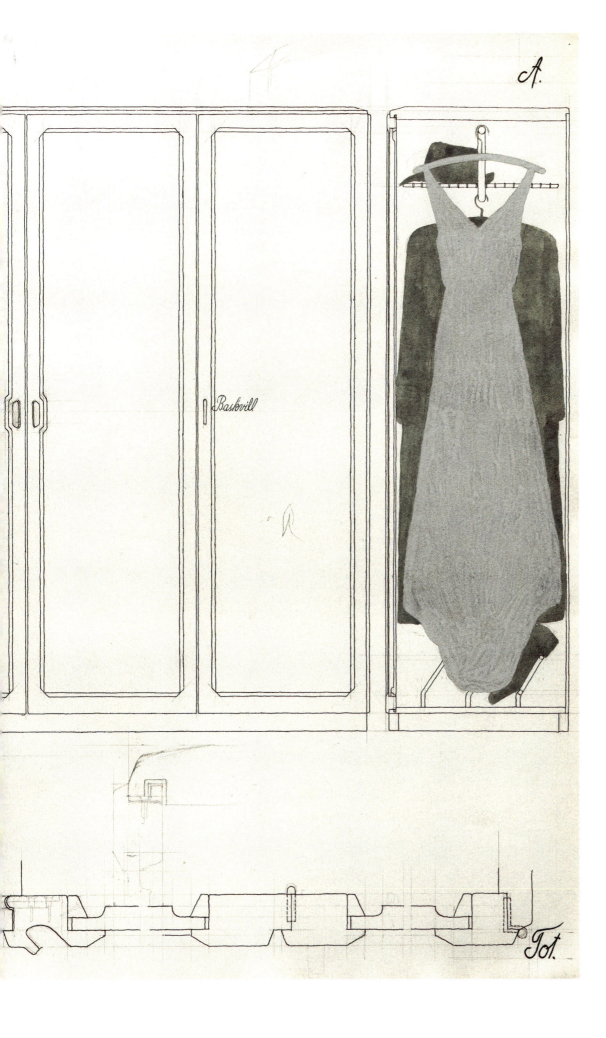

MoMA competition

'We have to move forward. We cannot say that we only want to work in the old materials. There might be something new to be gained,' Wegner was quoted as saying in 1974. He was not afraid to think innovatively, including in terms of materials. He proved this when, in 1948, he submitted several furniture designs to a competition launched by the Museum of Modern Art in New York to create new furniture designs that could be produced cheaply. In his chair designs submitted for the competition, Wegner used moulded plywood, a light, industrially processed and cheap material. Wegner's MoMA chairs never went into production, but they did serve as the starting point for his later shell chairs, including the Tripartite Chair from 1949 and the even more famous Shell Chair from 1963.

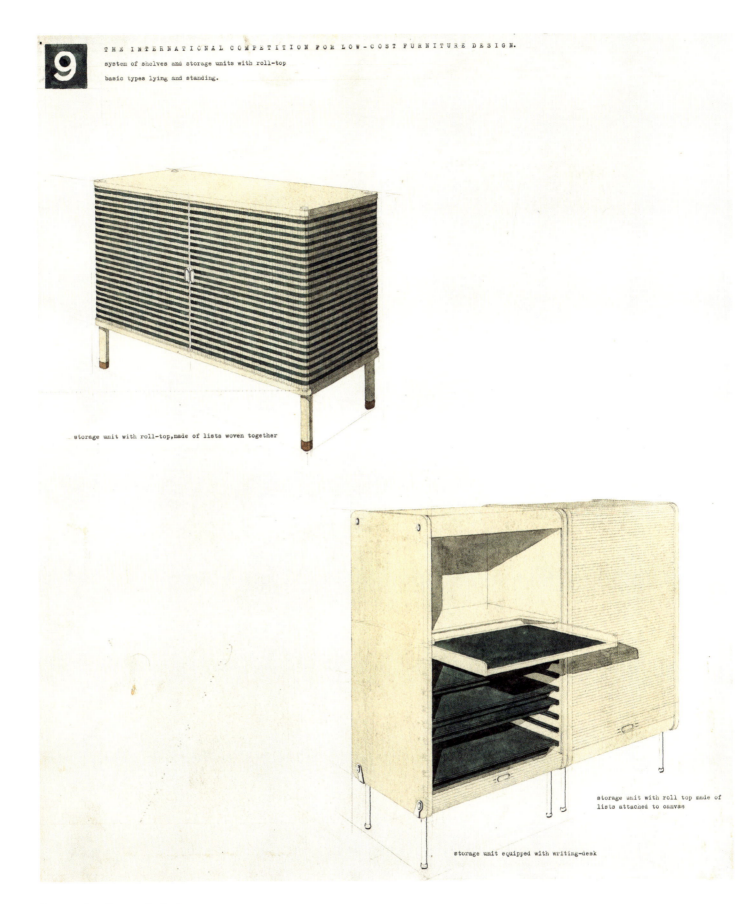

Storage furniture, submission for the Museum of Modern Art's International Competition for Low-Cost Furniture Design
Perspective views
Pencil, pen and typewriter
1948

International competition for low-cost furniture design.
easy chair with seat and back made of plywood, and underframe made of wood; detachable cushion on back – scale 1:4.
component parts can be piled.

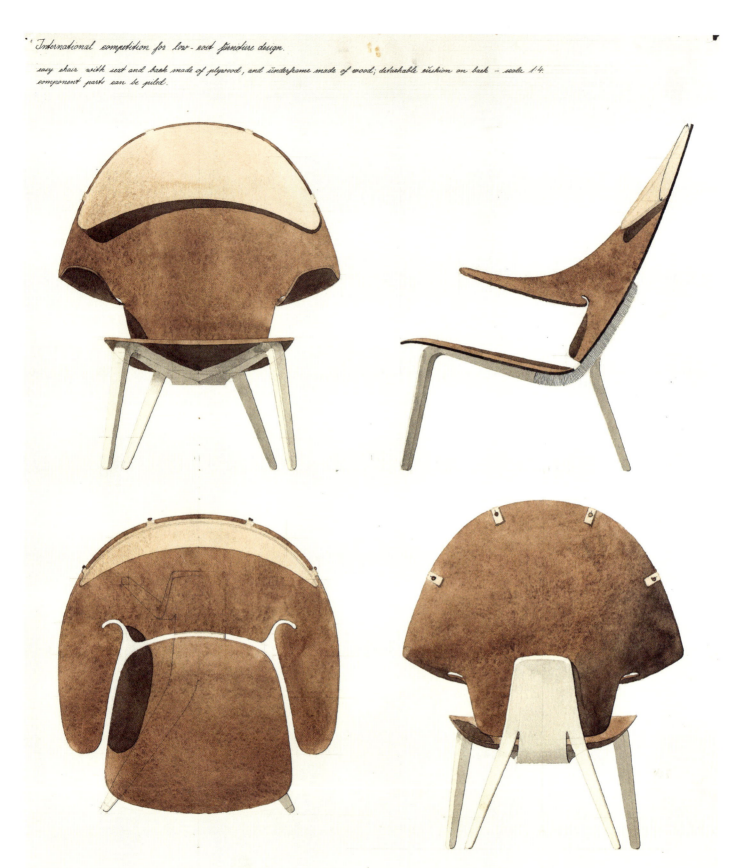

**Armchair, submission for the Museum of Modern Art's
International Competition for Low-Cost Furniture Design**
Plan and elevations
Pencil, pen and watercolour
1948

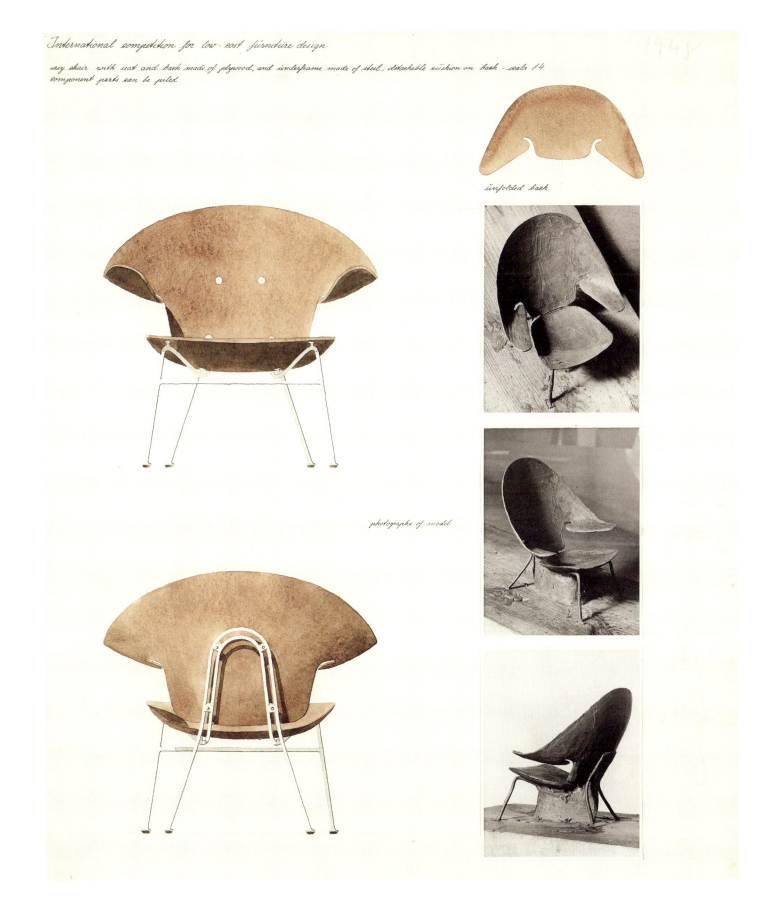

Armchair, submission for the Museum of Modern Art's International Competition for Low-Cost Furniture Design
Elevations and model
Pencil, pen, watercolour and photos
1948

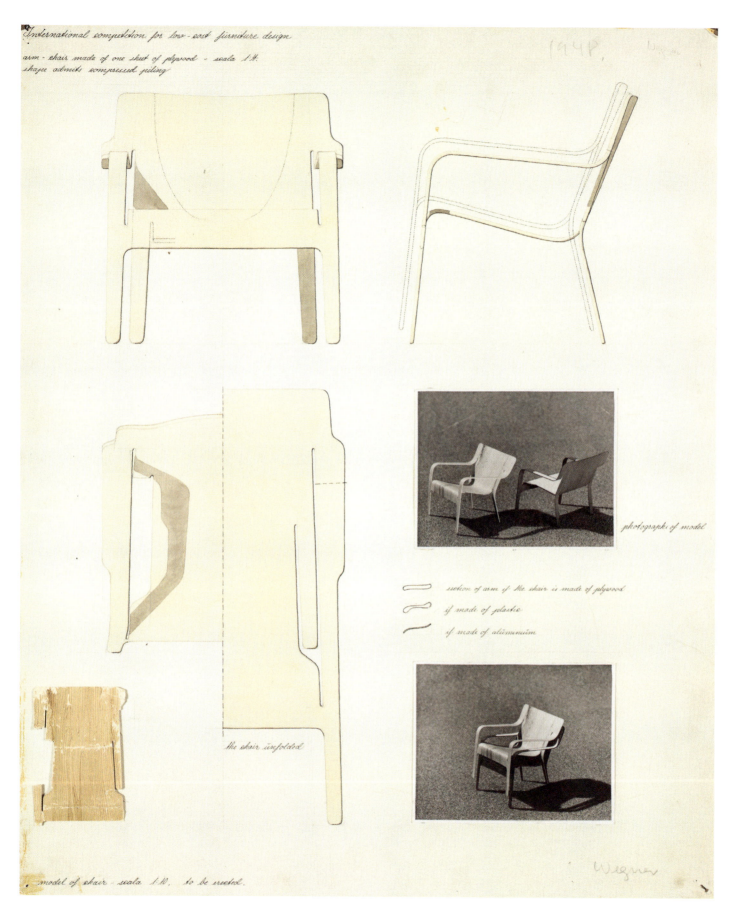

**Chair with armrests, submission for the Museum of Modern Art's
International Competition for Low-Cost Furniture Design**
Plans, elevations and models
Pencil, pen, watercolour and photos
1948

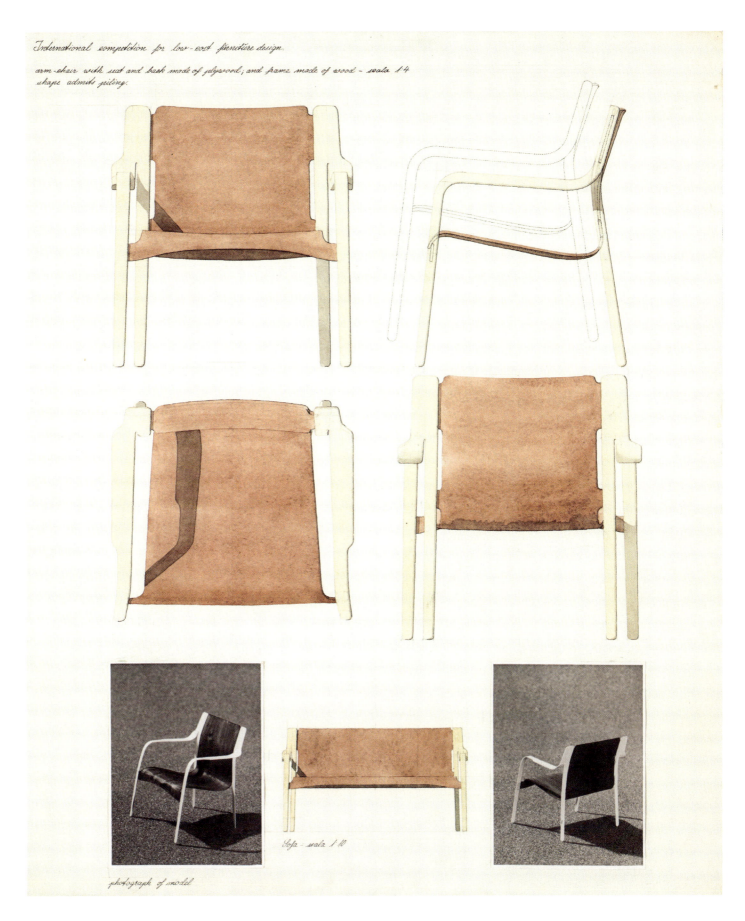

Chair and bench with armrests, submission for the Museum of Modern Art's International Competition for Low-Cost Furniture Design
Plans, elevations, and models
Pencil, pen, watercolor, and photographs
1948

Woodwork designs

Wegner flirted with the art of woodwork right from his early youth. It began with an interest in carving figures at a very young age, and during his days as an apprentice and journeyman at the carpentry workshop in Tønder it was not uncommon to embellish furniture with decorative wooden details. In the early 1940s, he took part in a competition launched by the Danish woodcarvers' guild and also created furniture with carved details for the furniture manufacturer Mikael Laursen. In 1944 Wegner designed the Fish Cabinet with elaborate intarsia on the doors and drawers, followed in the coming years by designs such as the Acorn Cabinet and the Crocodile Cabinet, all as part of his efforts to integrate an old craft into modern furniture production.

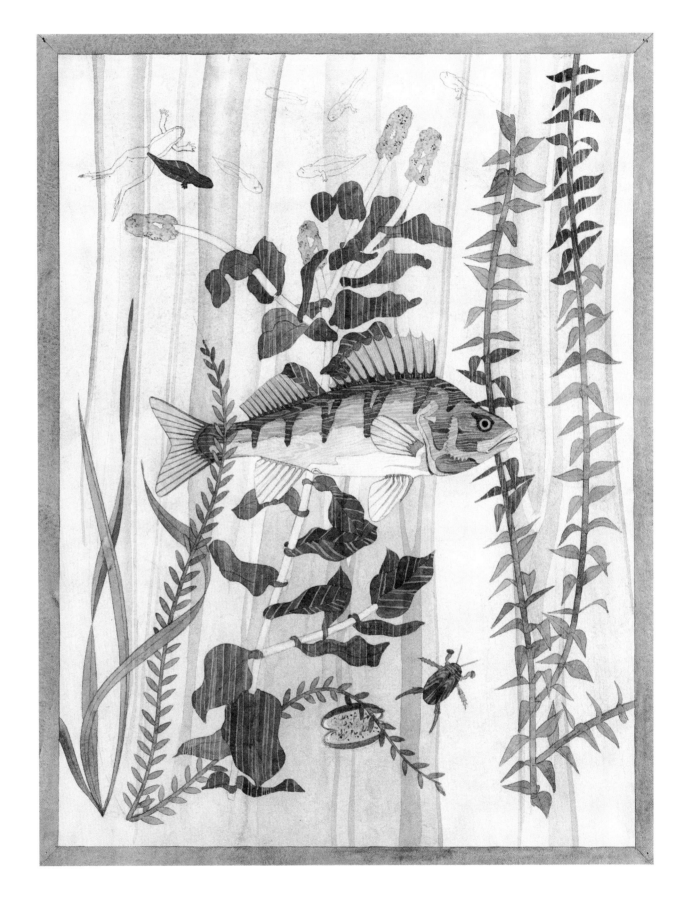

Fish Cabinet (left door)
Pencil and watercolour
Undated

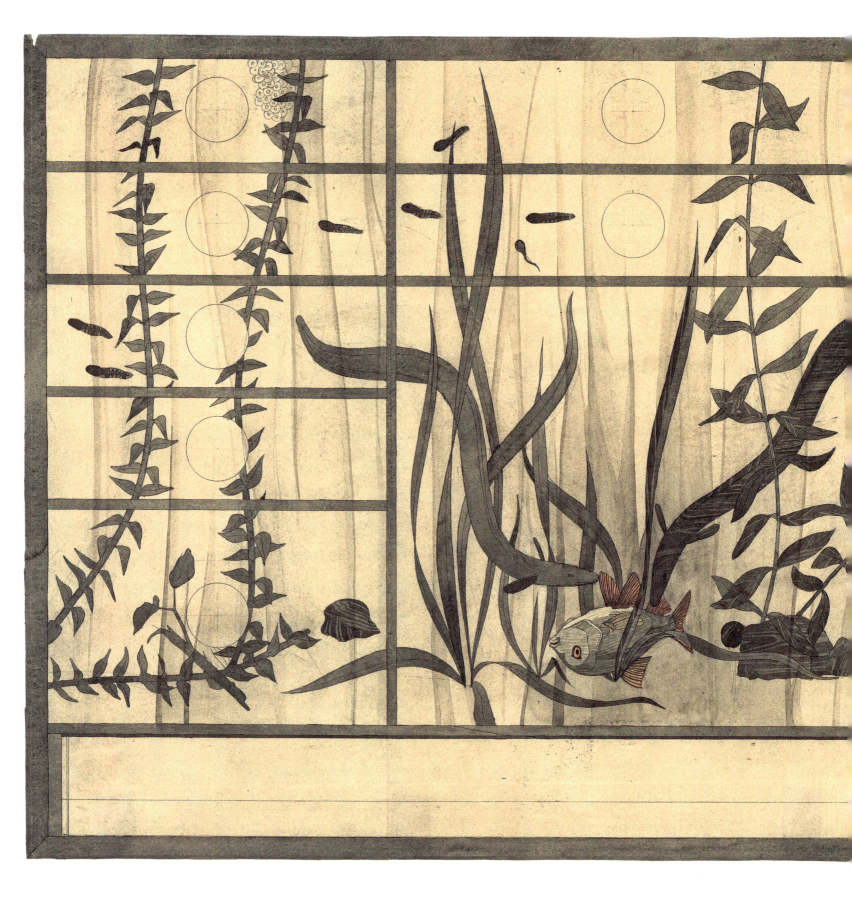

Fish Cabinet (middle section)
Pencil and watercolour
Undated

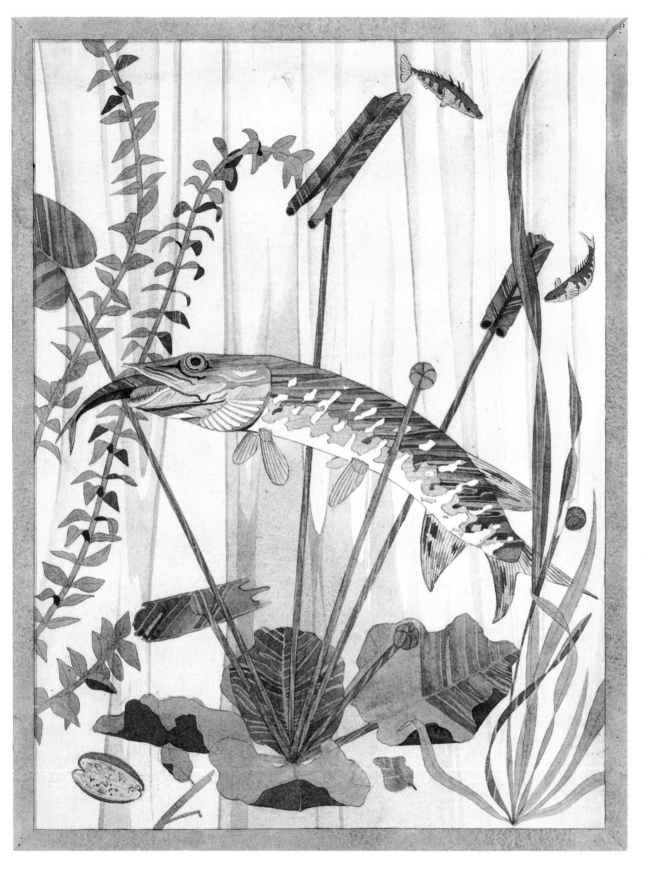

Fish Cabinet (right door)
Pencil and watercolour
Undated

Desk, Fish Cabinet
Plan, sections, elevation and details
Pencil, pen and watercolour
Undated

MÖBLER TIL EN SPISESTUE.
SKABET UDFØRES AF PALISANDER OG AHORNTRÆ.

SERVICESKAB MED BAKKER OG SKUFFER. 1:5

DETAIL AF

Dining room furniture
Plan, elevations and details
Pencil, drawing ink and watercolour
Undated

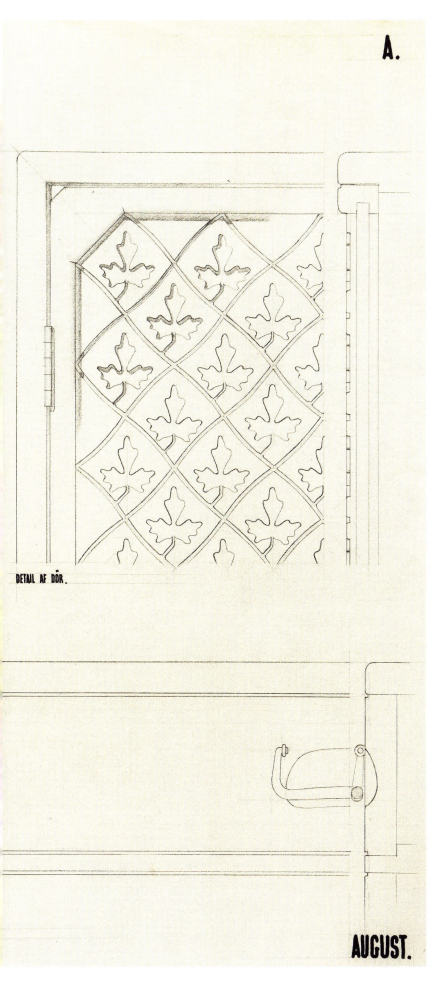

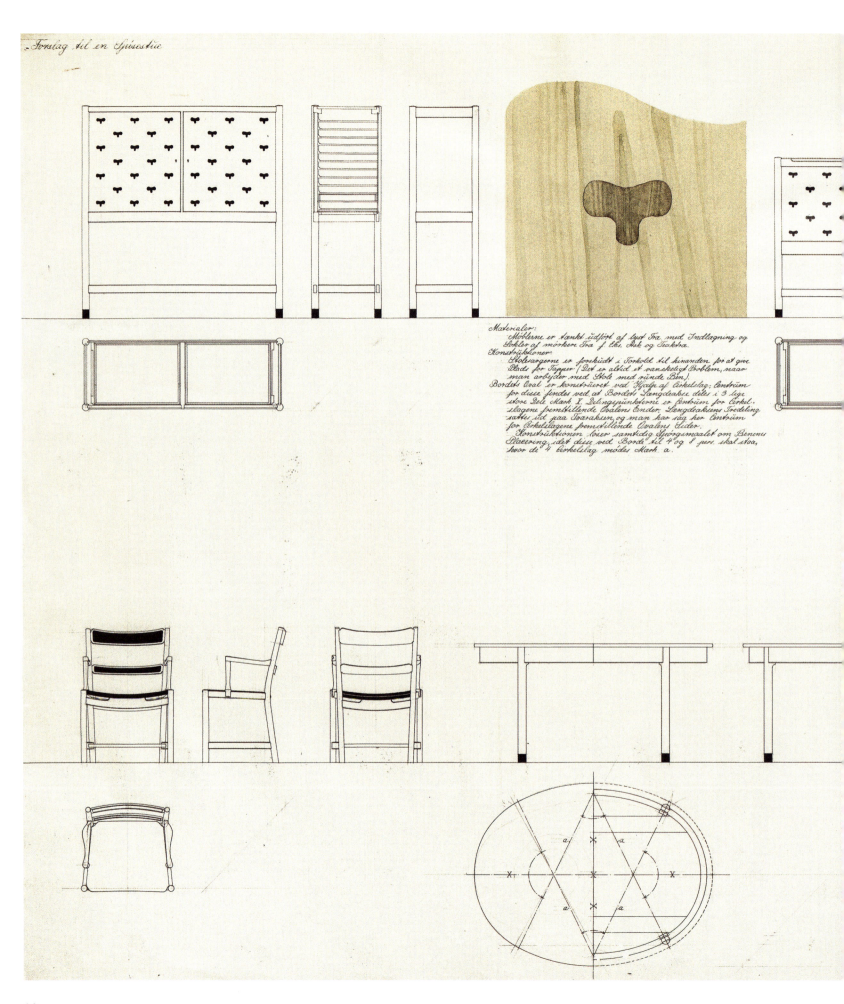

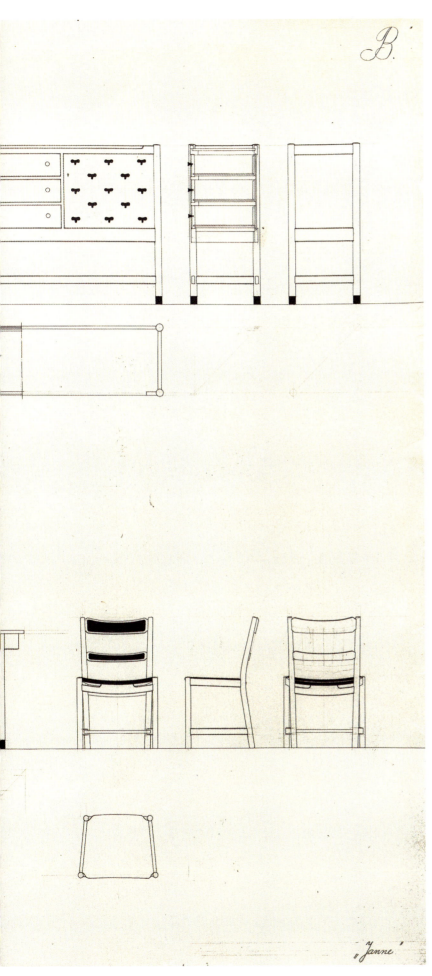

Proposals for a dining room
Plans, elevations and details
Pencil, pen and watercolour
Undated

Furniture for a dining room
Plans, elevations and details
Pencil, pen, drawing ink and watercolour
Undated

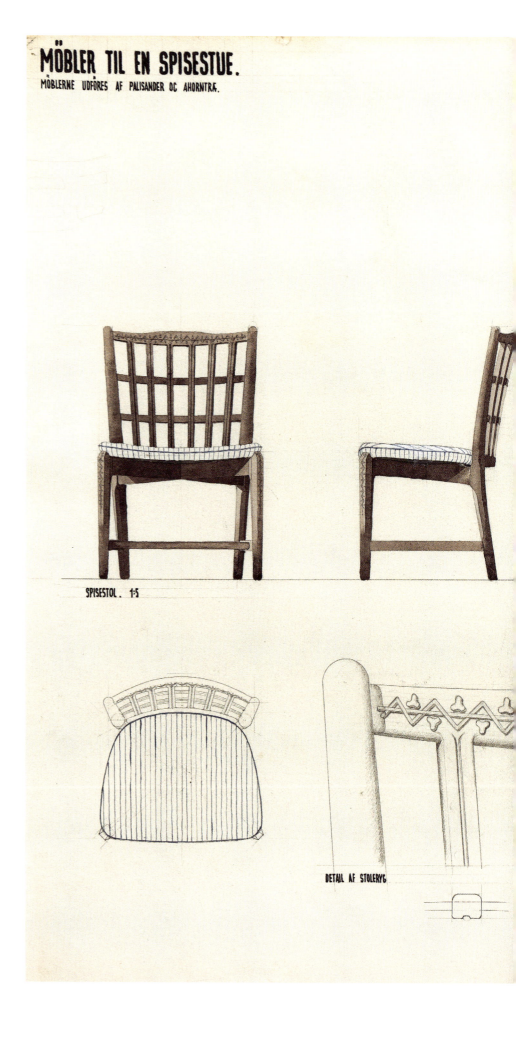

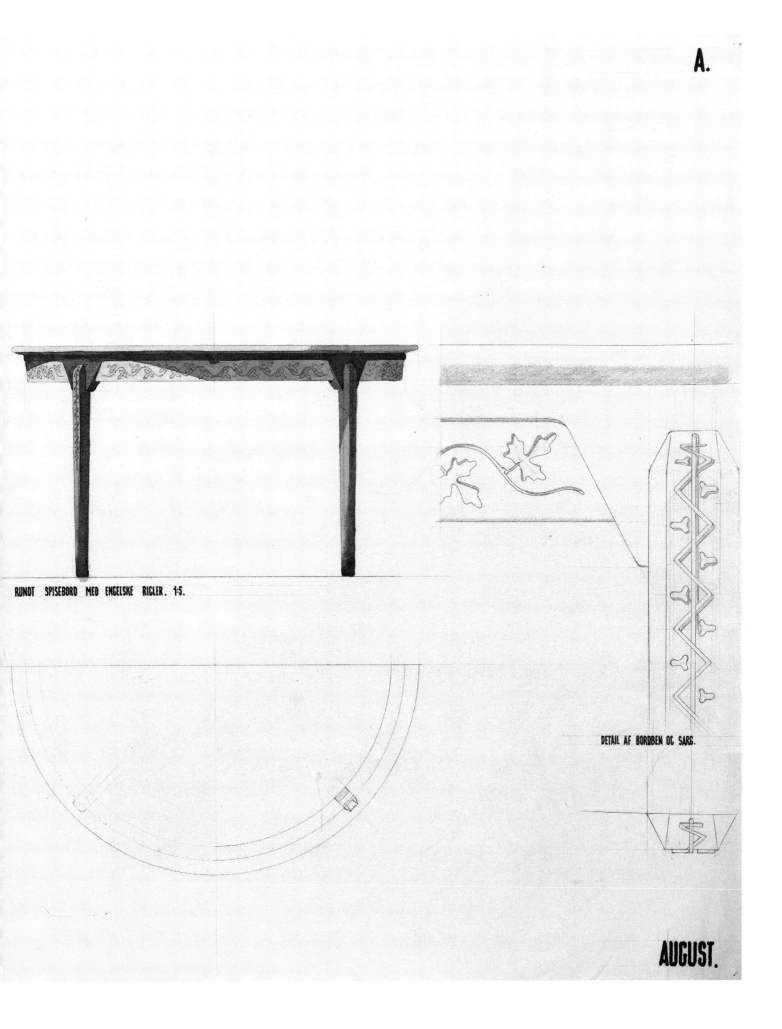

BILLEDSKÆRERLAUGET'S KONKURRENCE.
SERVICESKAB MED SKUFFER OG JALOUSI. 1:5

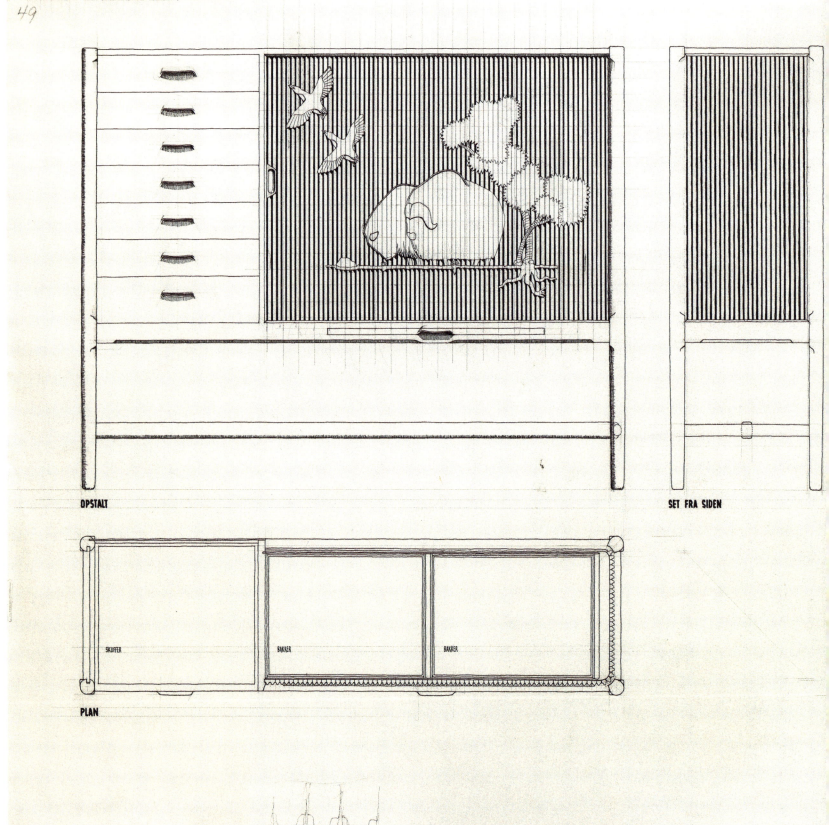

OPSTALT · SET FRA SIDEN · PLAN

China cabinet with drawers and tambour doors, submission for a design competition
Plan, layout and perspective
Pencil, pen and marker
Undated

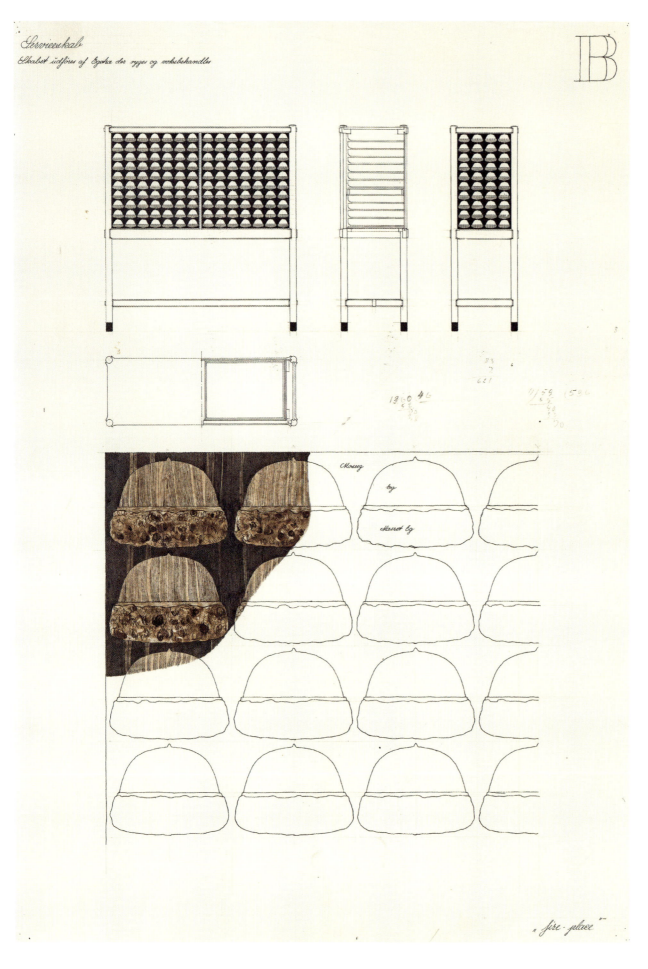

China cabinet
Plan, elevations and detail
Pencil, pen, drawing ink
and watercolour
Undated

Cabinet types
Plan, elevations and details
Pencil, pen and watercolour
Undated

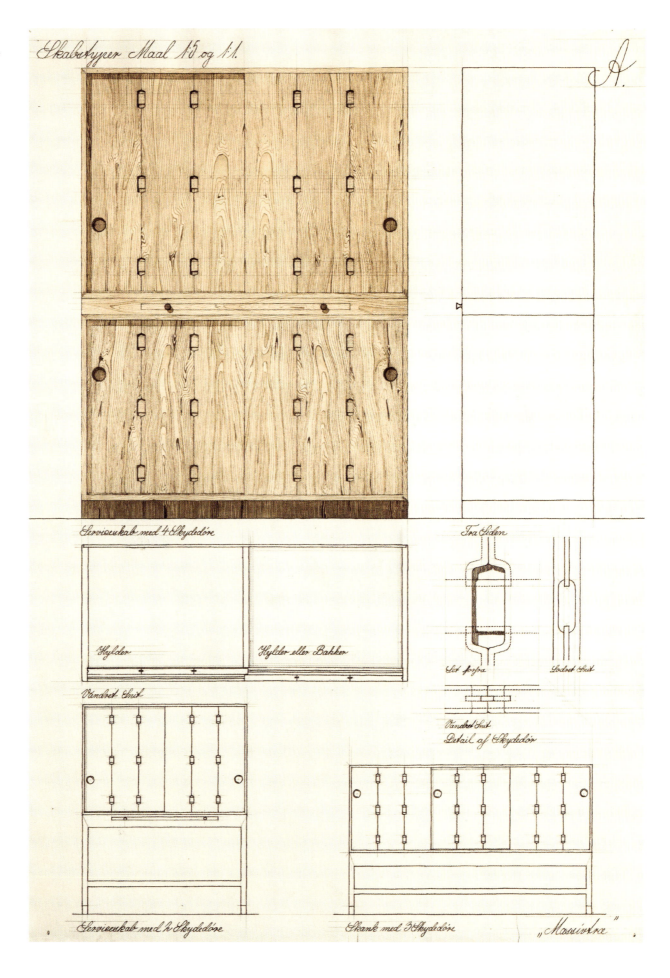

Animals, figures and people

'While I was at The School of Decorative Art, they told me that I ought to be a portrait painter,' stated Wegner in the 1970s. Whether the school was right in this assessment is difficult to judge from the material available, but Wegner certainly had a gift for imbuing his animals, figures and people with character and vivid expressions. Some of the animal drawings are loose ideas for woodcarving projects, while his preoccupation with Buddha figures remains something of an enigma. It is conceivable that he was fascinated by the face and sought to capture its exalted serenity. The main work here is the portrait of Børge Mogensen, in which Wegner succeeds in capturing his sitter's appearance and personality through simple means.

Croquis study, male nude
Pencil and drawing ink
1938

**Croquis study,
female nude**
Pen
1938

101

Croquis study, female nude
Drawing ink
1938

Croquis study, male nude
Drawing ink
1938

Croquis study, male nude
Drawing ink
1938

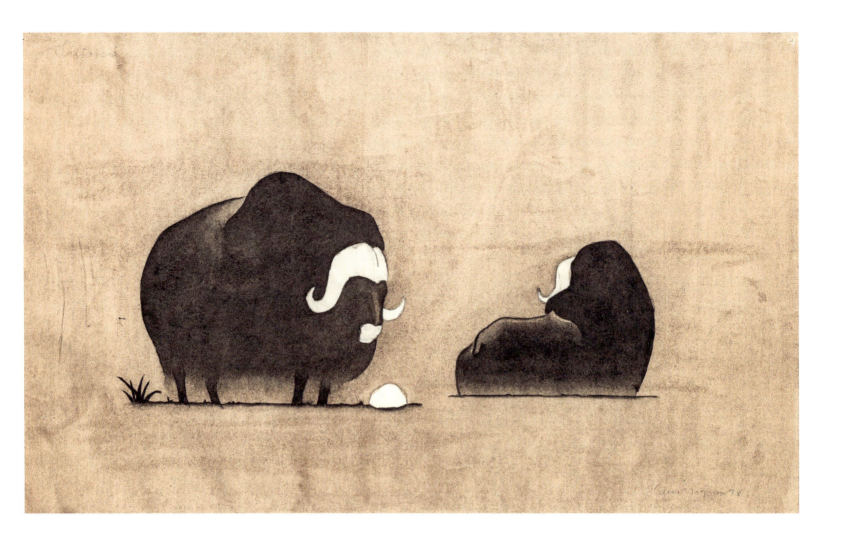

Oxen (intarsia design)
Watercolour
1938

Calves
Pen and watercolour
Undated

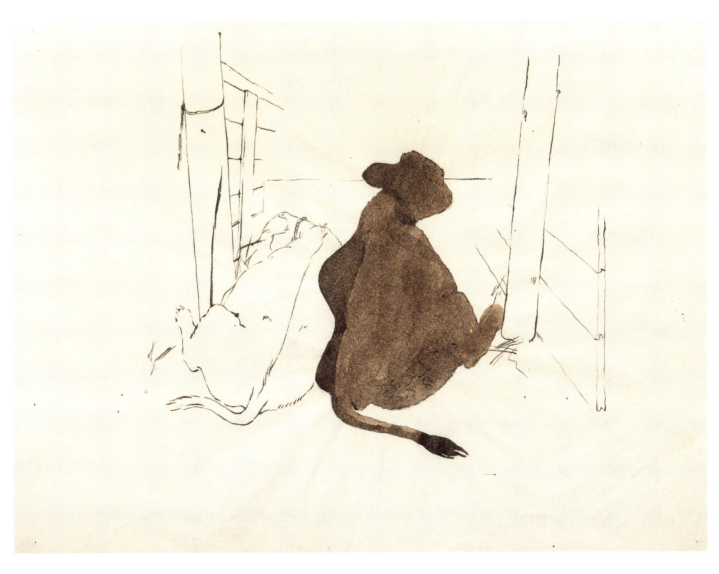

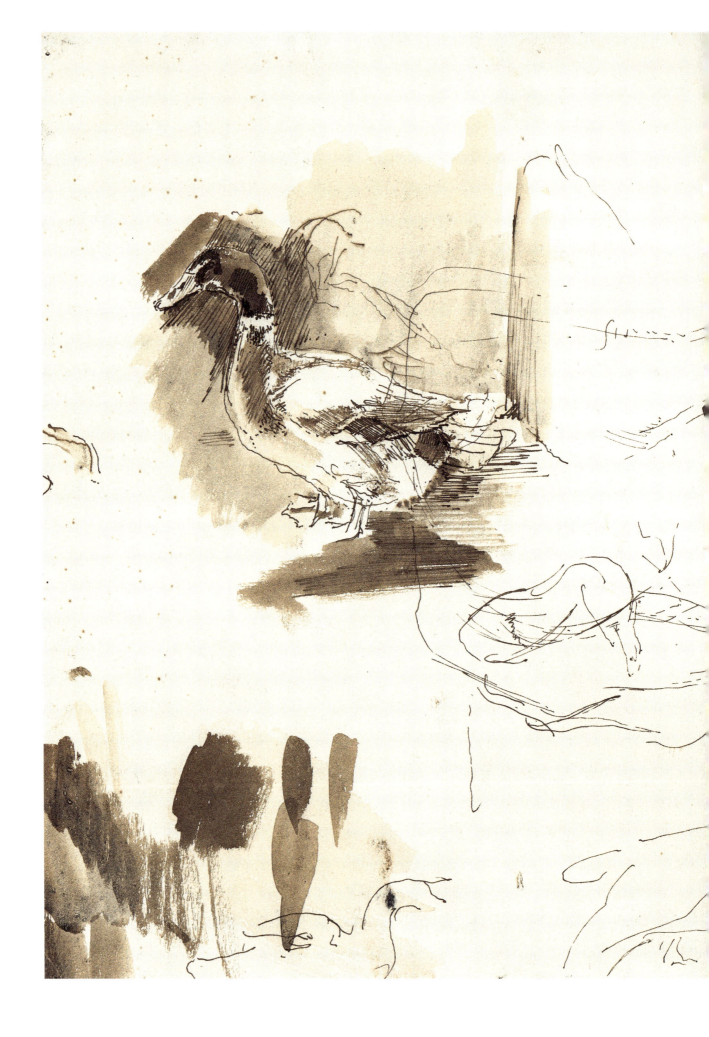

Study of ducks
Pen and watercolour
Undated

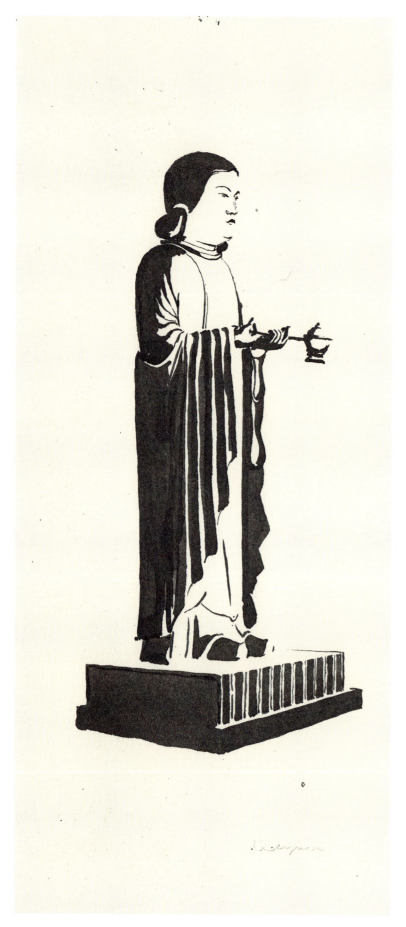

Asian figure
Drawing ink
Undated

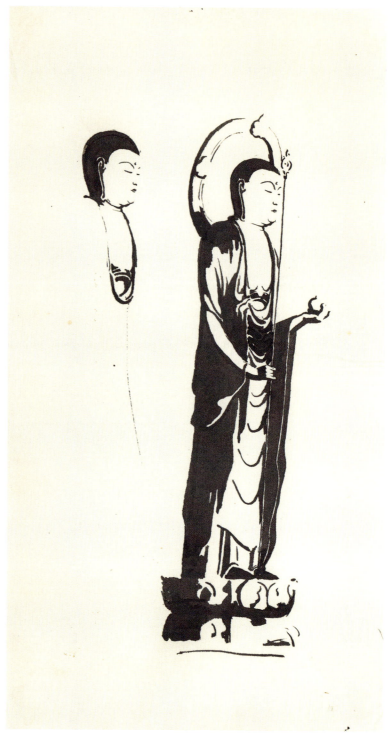

Head of a Buddha and Buddha, standing
Drawing ink
Undated

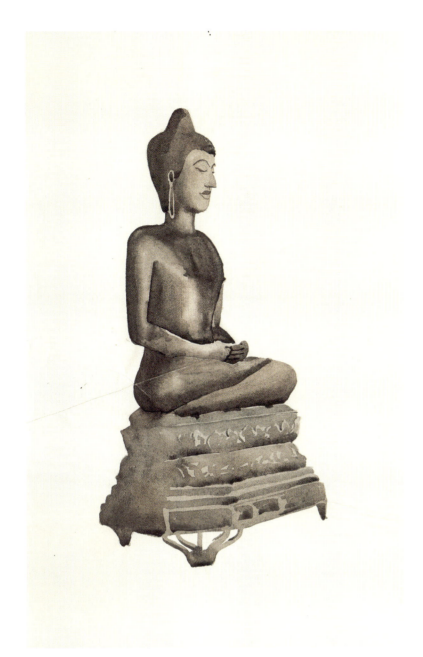

Buddha figure
Watercolour
Undated

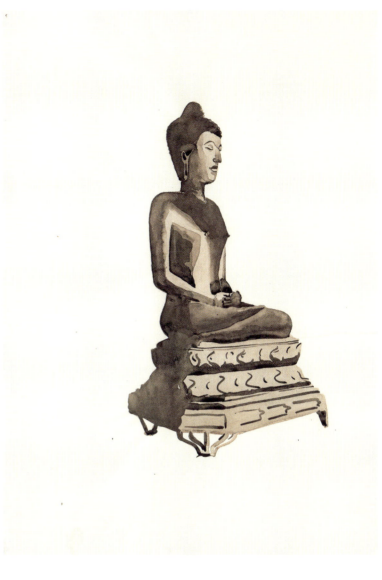

Buddha figure
Watercolour
Undated

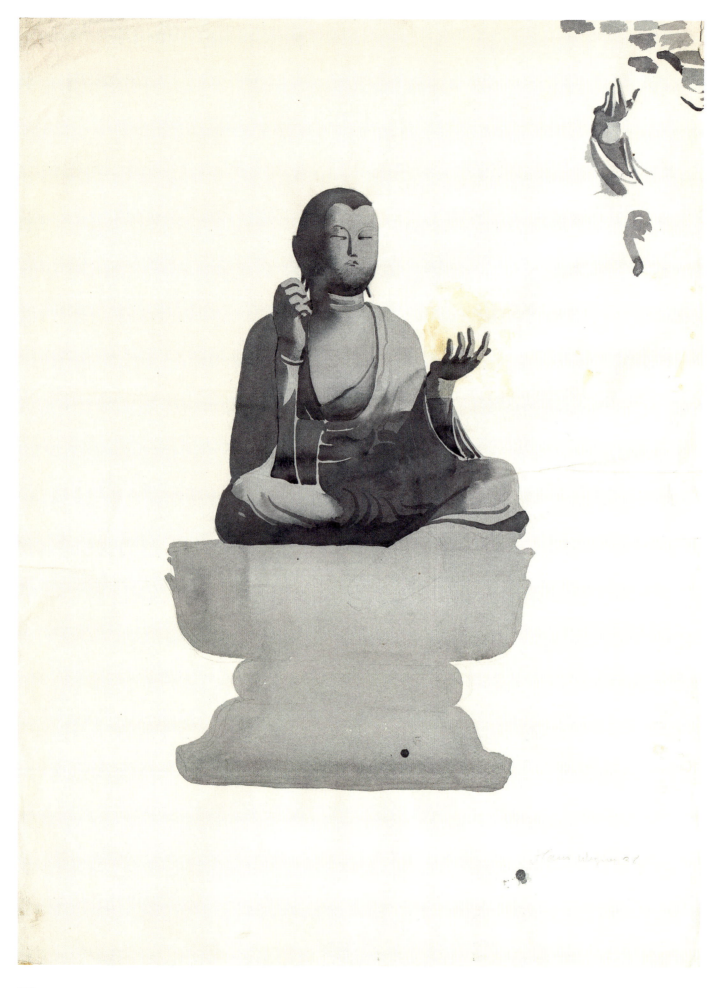

Buddha figure
Watercolour
Undated

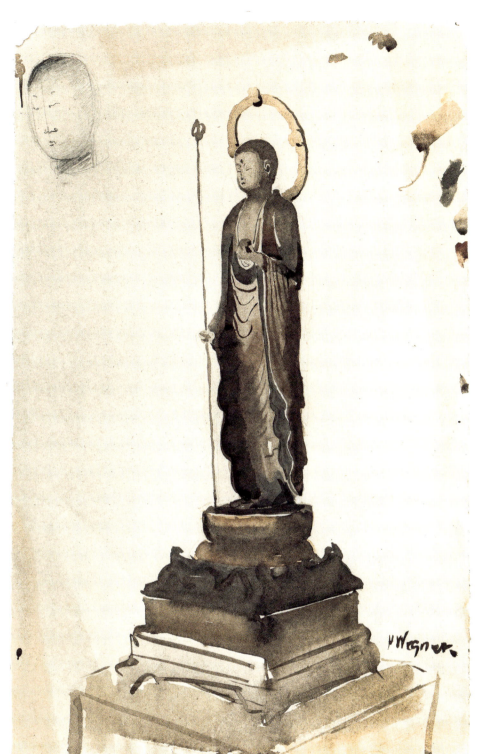
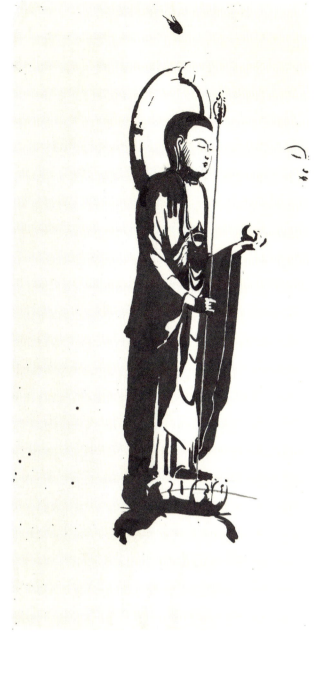

Buddha, standing
Watercolour
Undated

Buddha, standing
Drawing ink
Undated

Portrait of Børge Mogensen
Pencil, drawing ink and watercolour
Undated

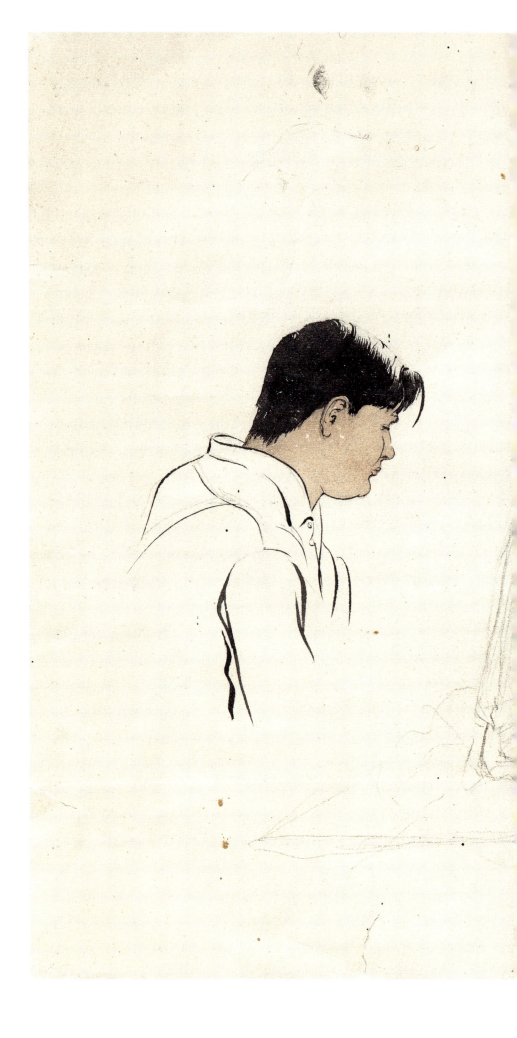

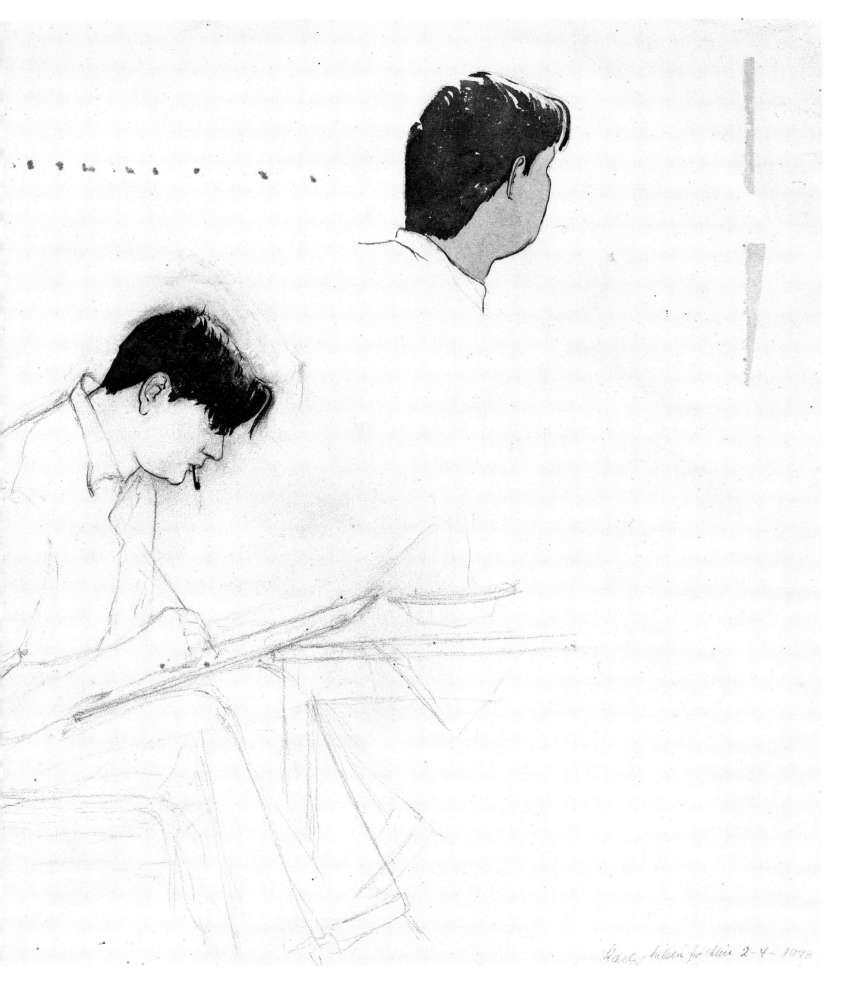

Buildings and landscapes

Wegner would rarely paint something simply for his own amusement. However, this small series of watercolours of buildings and landscapes served no practical or professional purpose. Here he has taken the time to paint something just because it interested him. In various interviews conducted through the decades, Wegner repeatedly expressed a fascination with buildings characterised by logical structures, and by buildings whose beauty resided in the use of natural, local materials. Themes like these might have been the starting point for the watercolours of the brick- and tileworks, the post mill and the house located in Møgeltønder. After leaving Tønder in 1935, Wegner only returned to take holidays and visit his family. But he never lost his childhood sense of connection with the Vidå river and the flat marsh landscape of the Tønder region, which he reproduced in a small series of landscape watercolours from the summer of 1941.

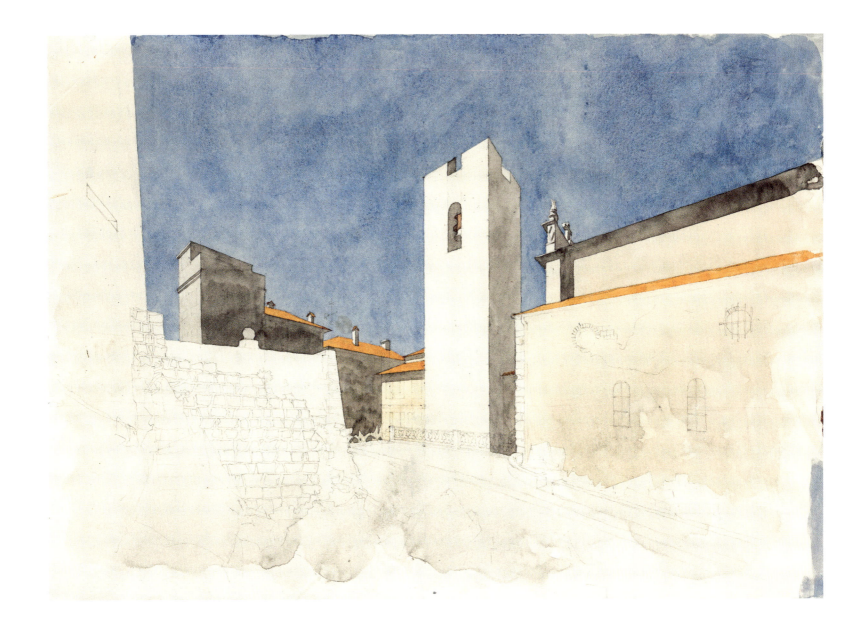

Bell tower in Antibes
Watercolour
Mid 1960s

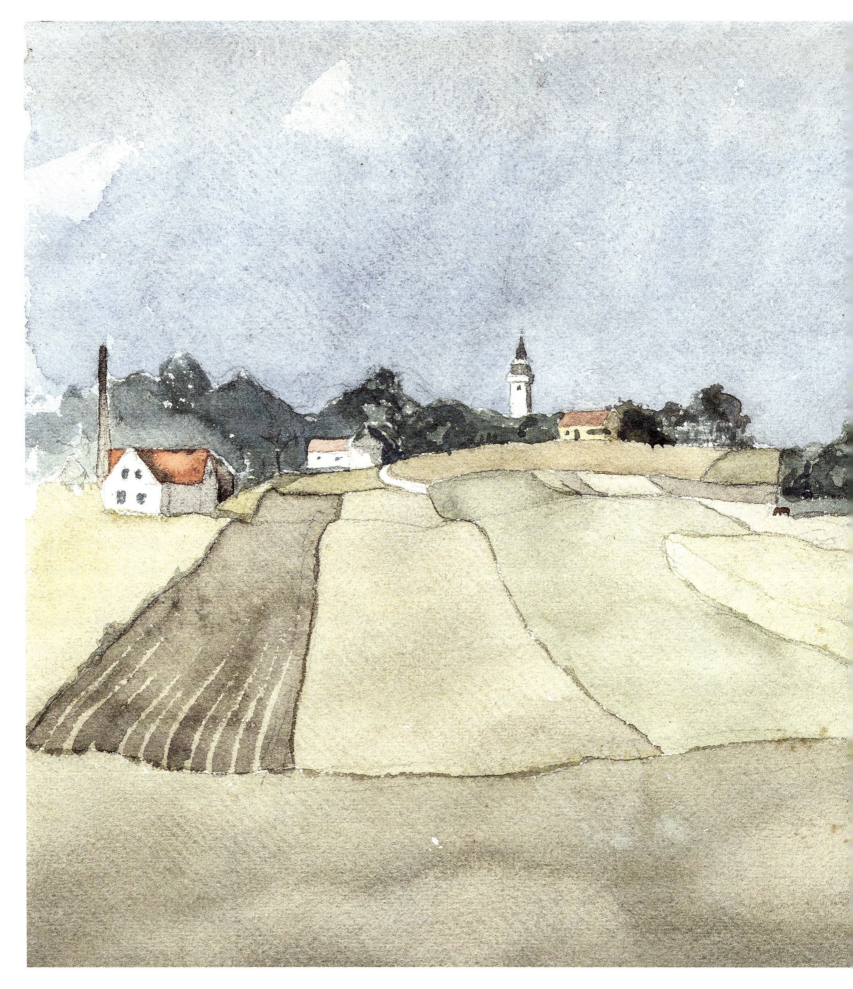

Landscape
Watercolour
1938

Brickworks
Watercolour
Undated

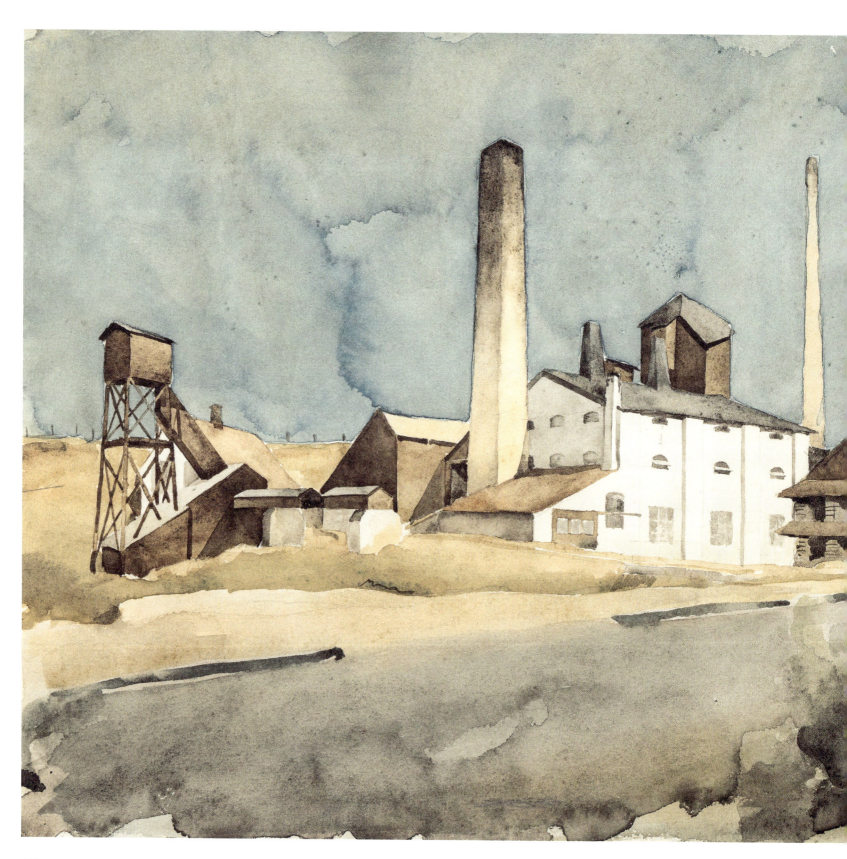

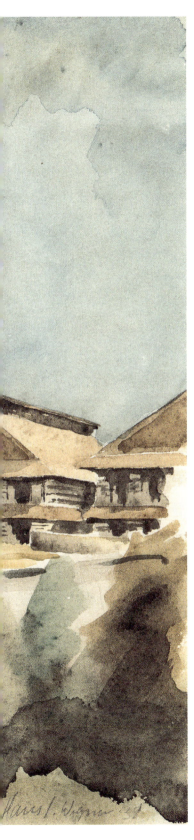
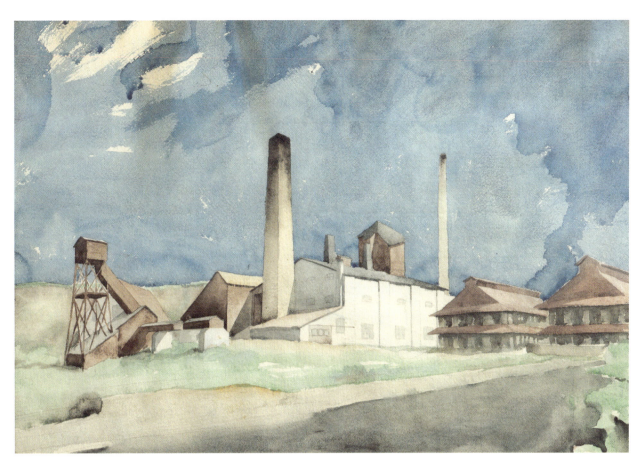

121

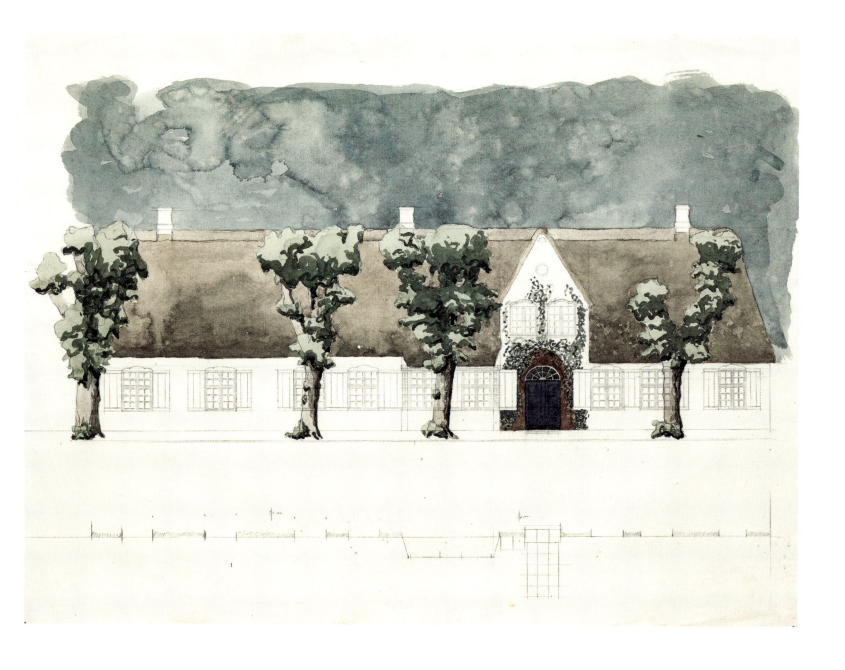

Town house in Møgeltønder
Elevation
Watercolour
Undated

Post mill
Watercolour
Undated

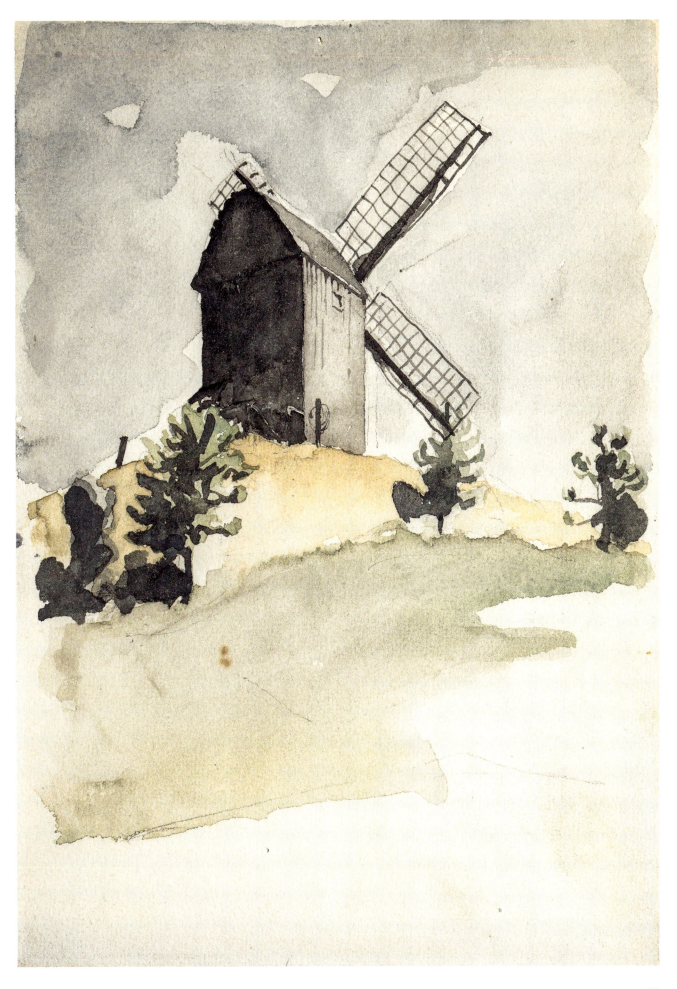

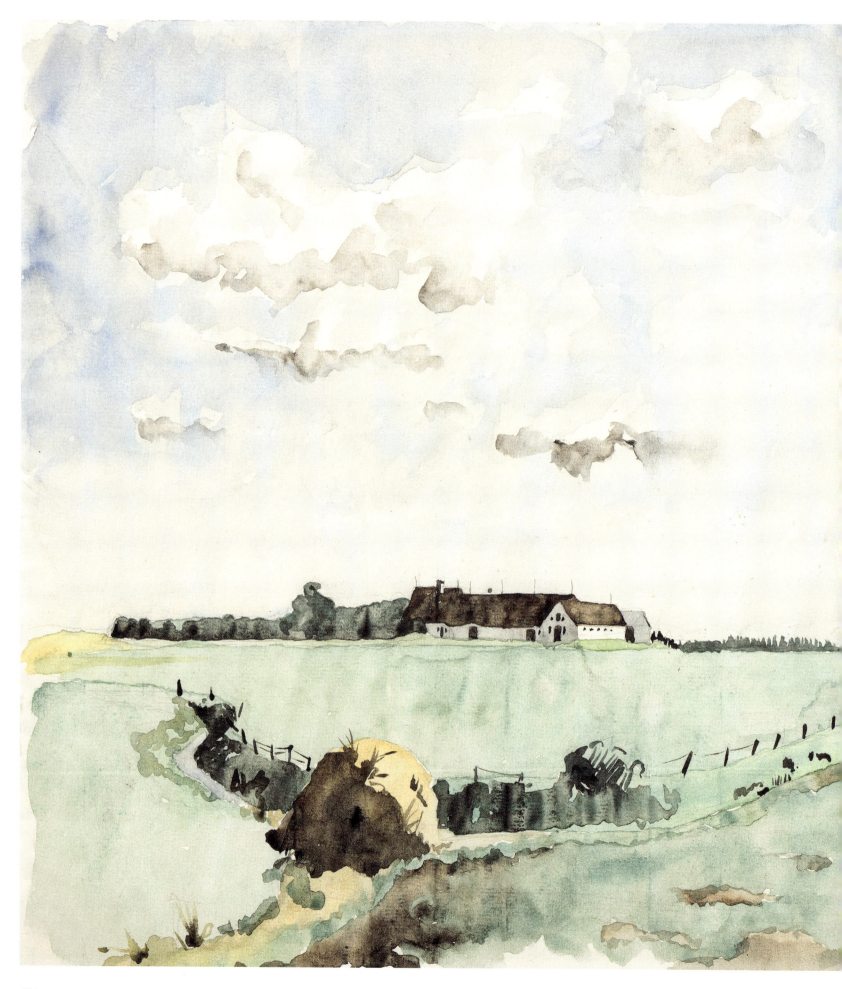

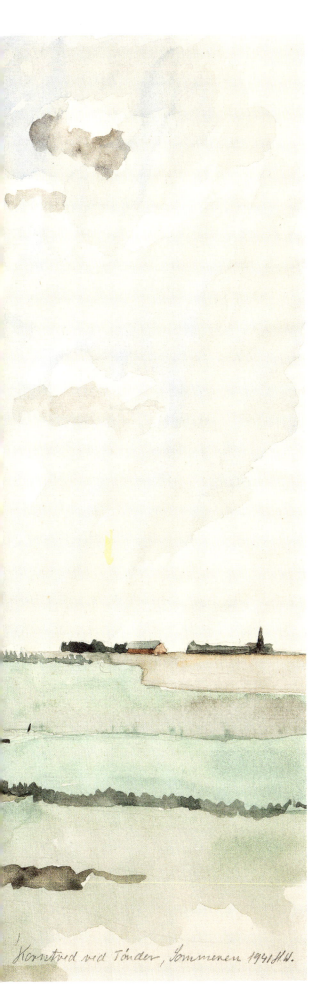

Korntved near Tønder (Hestholm)
Watercolour
1941

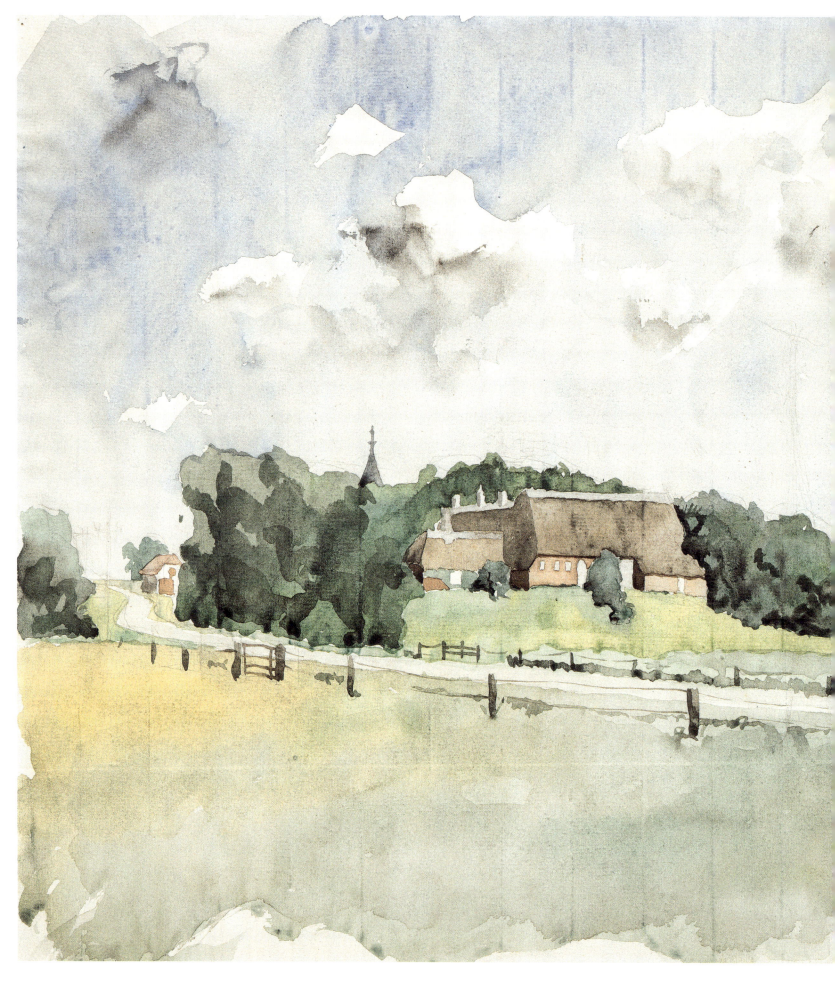

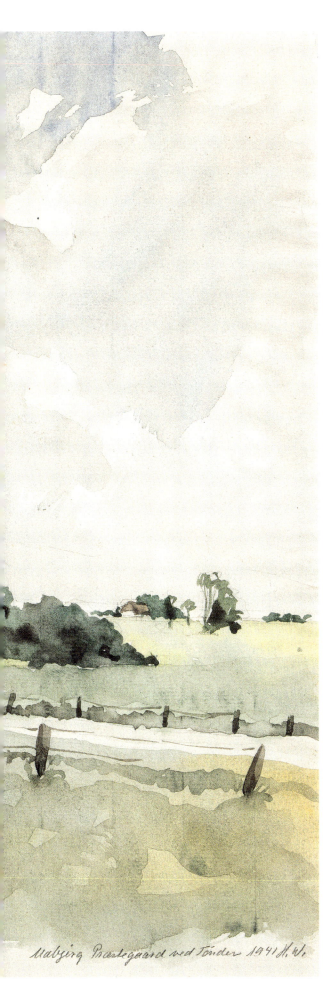

Ubjerg vicarage
Watercolour
1941

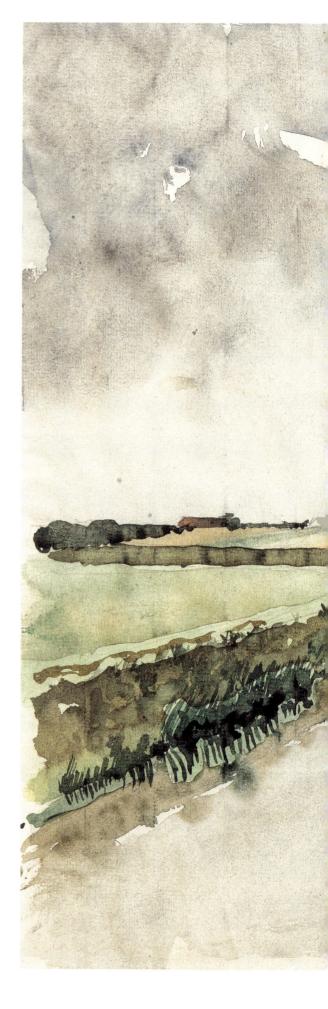

View from the Vidå river near Tønder
Watercolour
1941

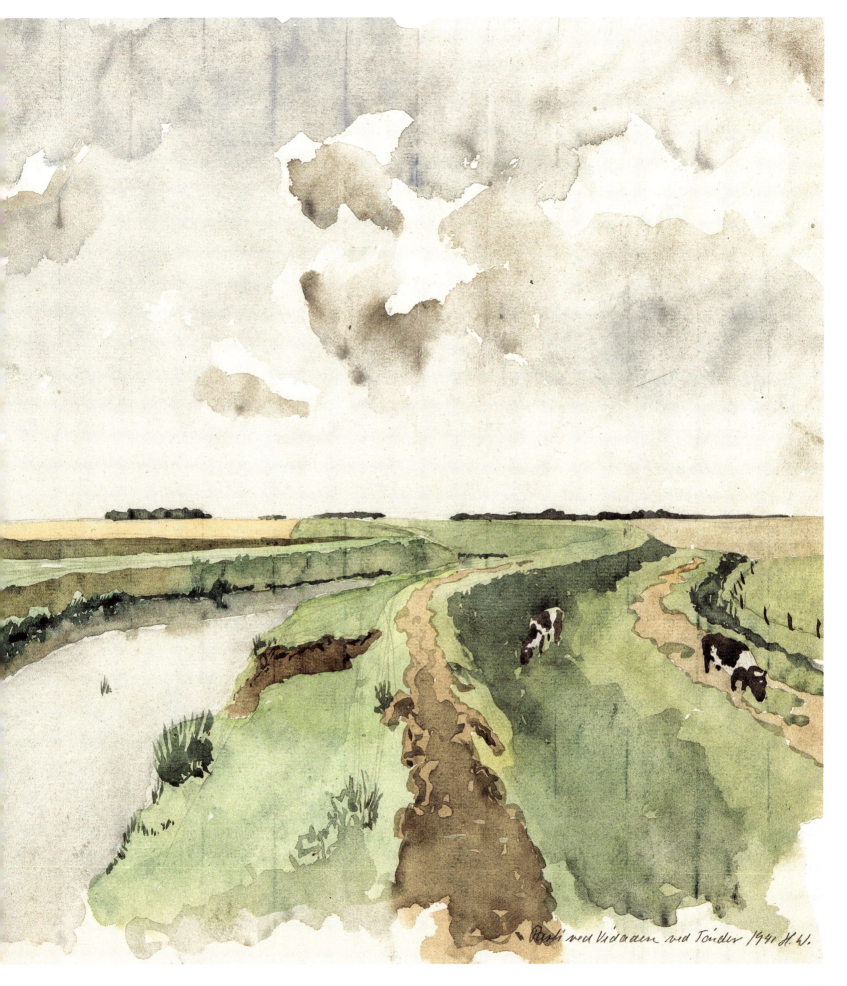

Interiors

Several of these watercolours date from Wegner's student days. They appear effortless – as if such work came easily to him. Indeed, he would come to work extensively with interior design for stretches at a time, both in his native Denmark and abroad. For example, he designed trade fair stands, exhibitions for The Danish Society of Arts and Crafts and Industrial Design, stands at The Cabinetmakers' Guild Exhibition and various rooms. His best-known interior is probably his design for a conference room in the UNESCO headquarters in Paris in 1958, while Danish examples include his design for the newspaper Politiken's canteen in 1984.

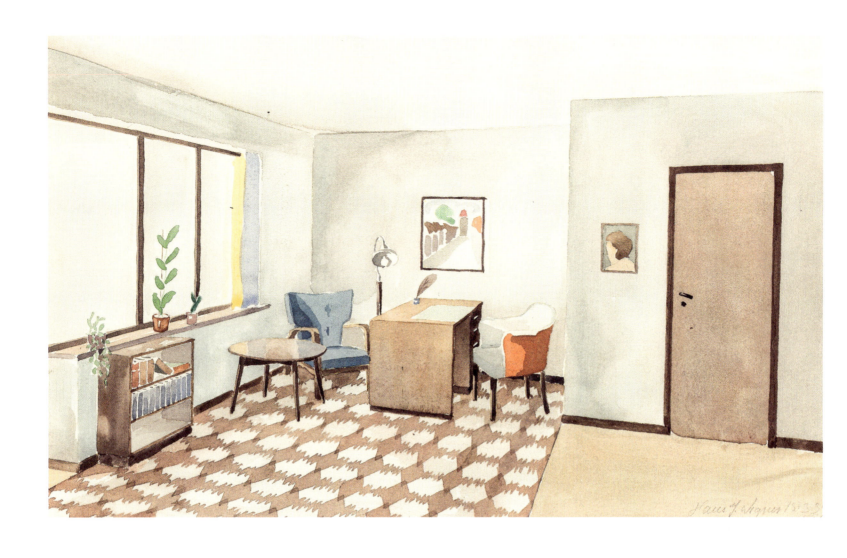

Office
Perspective view
Pencil and watercolour
1937

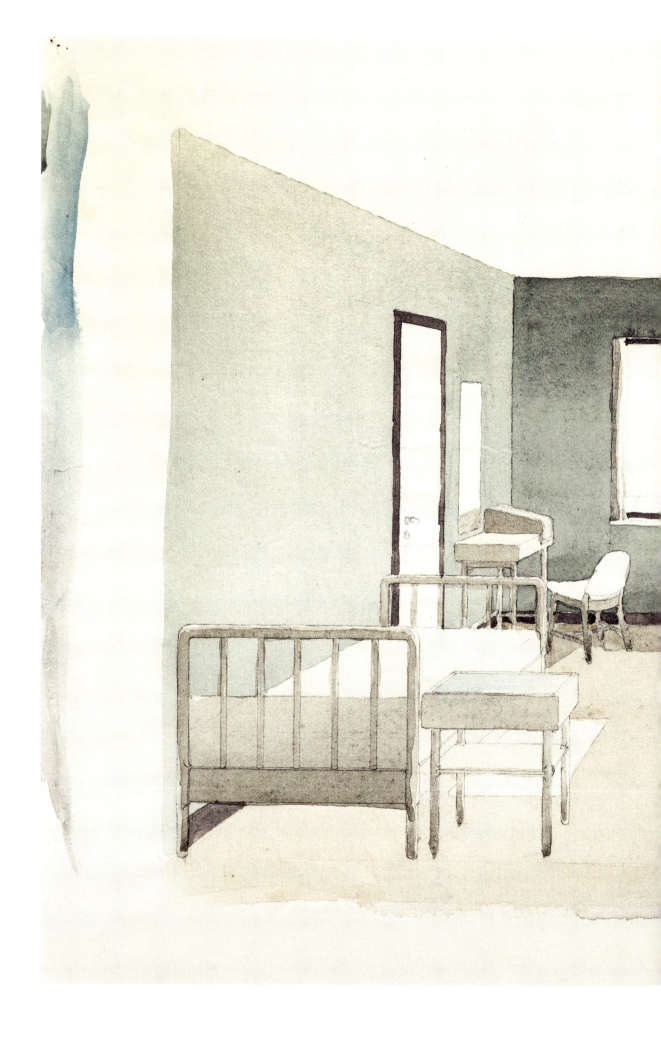

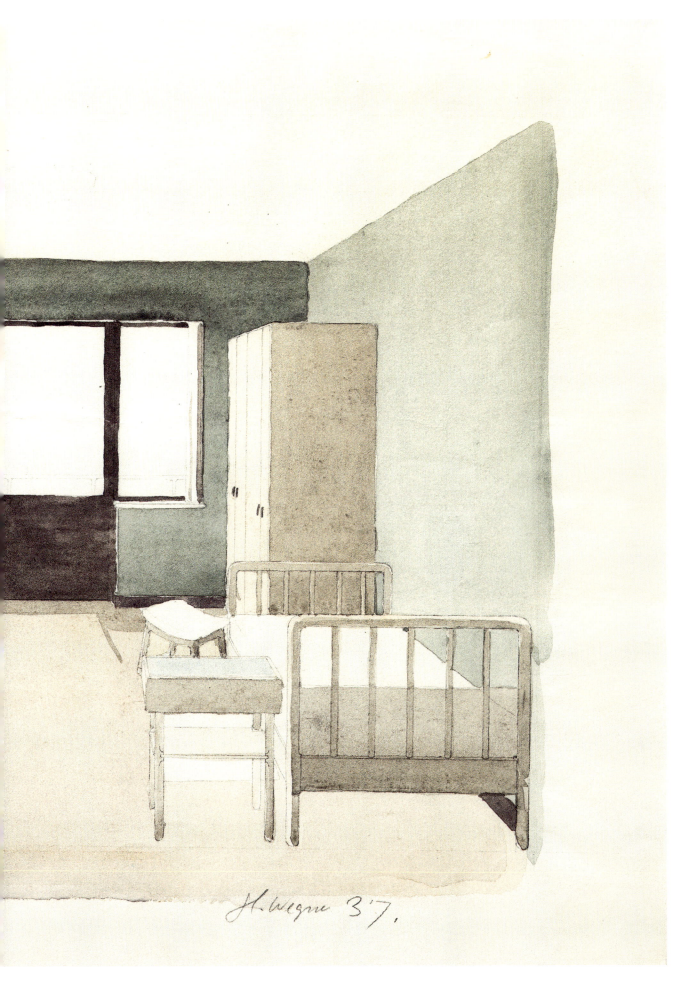

Bedroom
Perspective view
Pencil and watercolour
1937

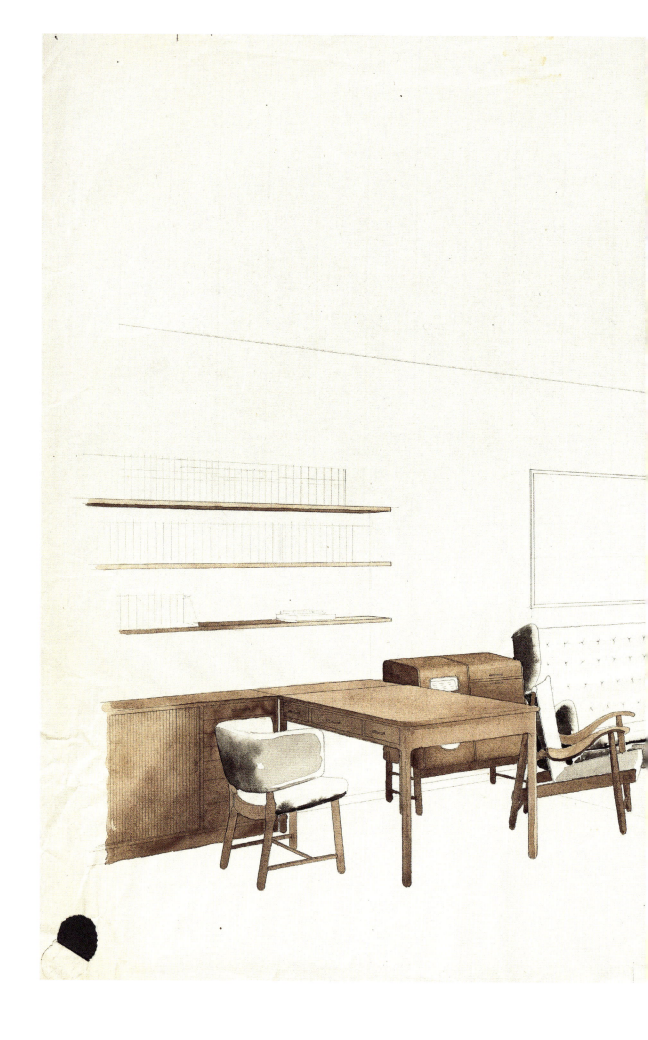

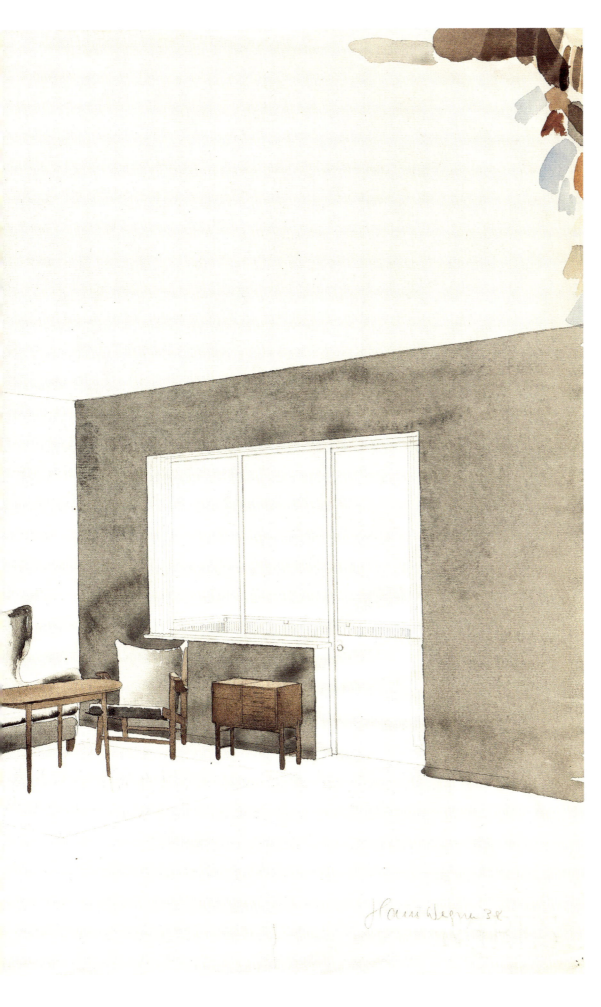

Sitting room
Perspective view
Pencil and watercolour
1938

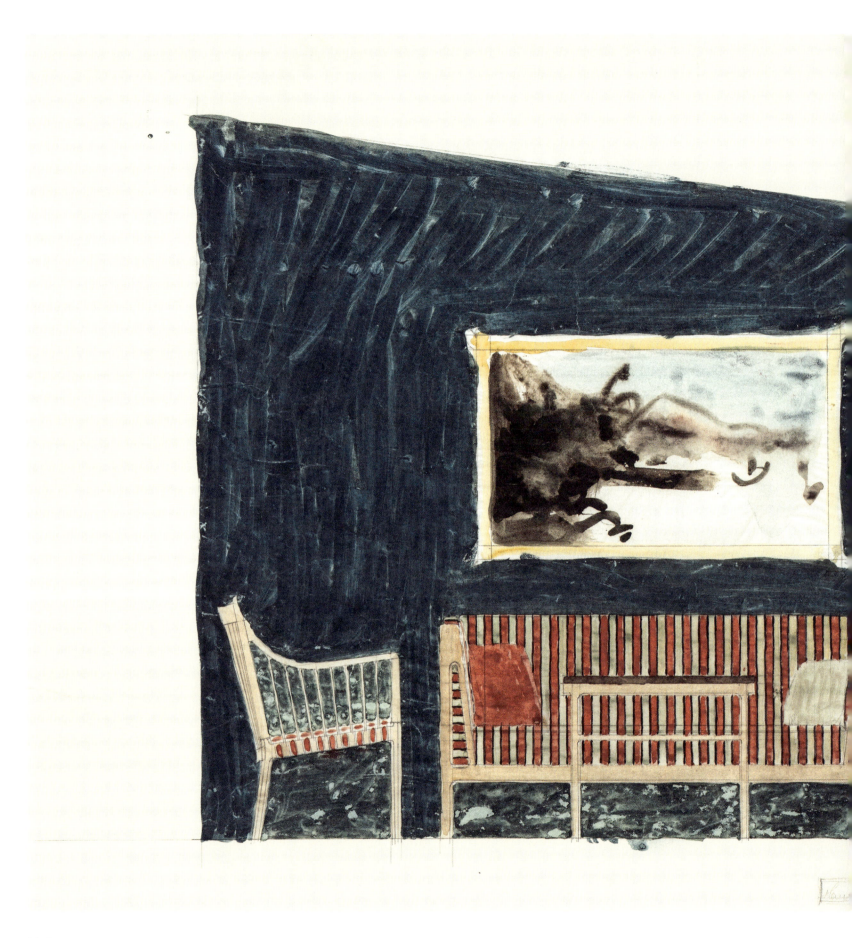

Sitting room
Elevation
Pencil and watercolour
Undated

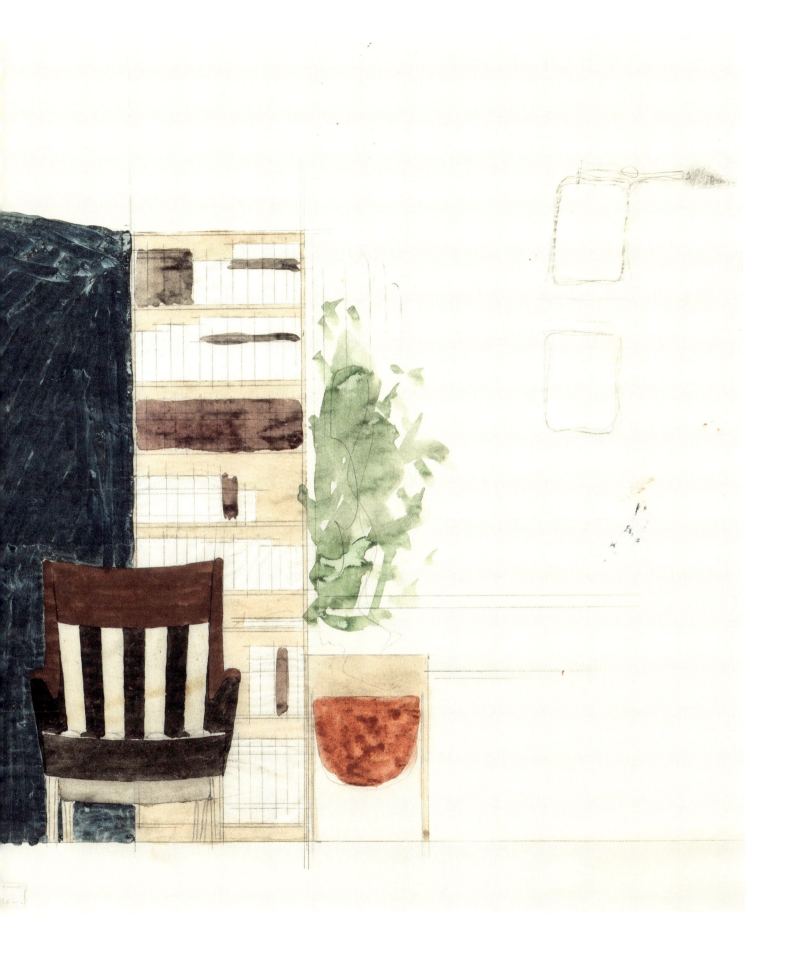

MÖBLER TIL EN OPHOLDSSTUE

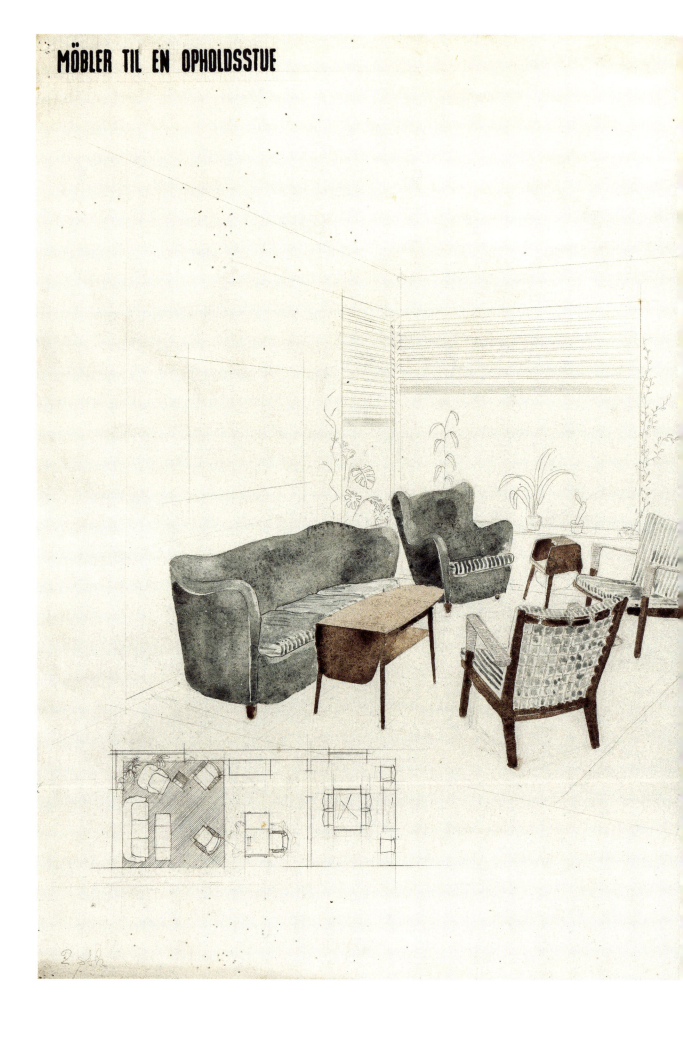

MÖBLER TIL EN OPHOLDSSTUE

Furniture for a living room
Perspective view and plan
Pencil and watercolour
Undated

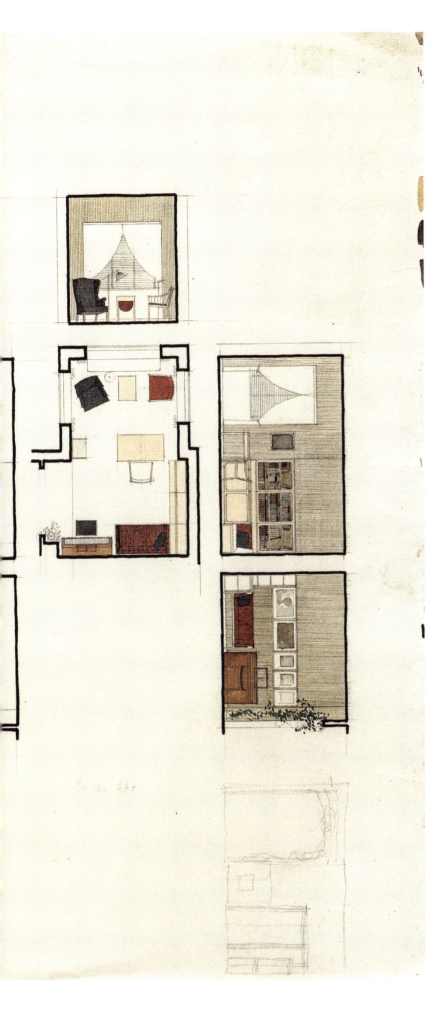

Living room
Floor plans and elevations
Pencil, pen, drawing ink and watercolour
Undated

PRIVATKONTORET.

Plan og Opstalter 1:20

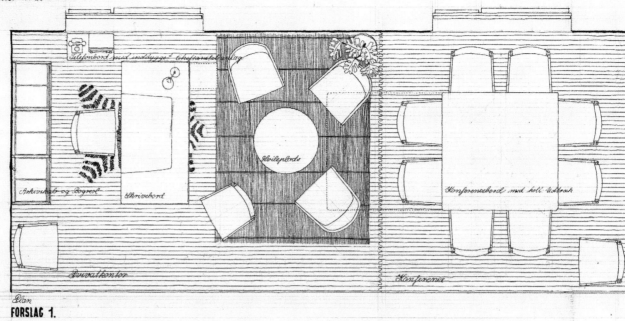

Plan
FORSLAG 1.

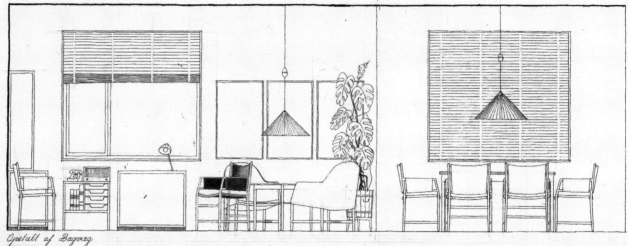

Opstalt af Bagvæg
FORSLAG 1.

Opstalt af venstre Endevæg
FORSLAG 1. OG 2.

Opstalt af Portiere
FORSLAG 1.

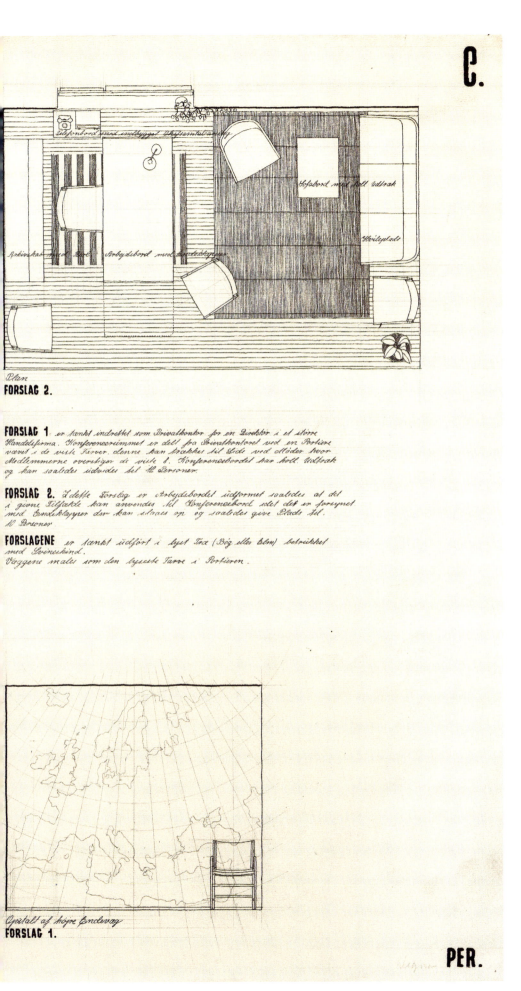

Private office
Floor plans and elevations
Pencil, pen, drawing ink and watercolour
Undated

Möbleringsplan

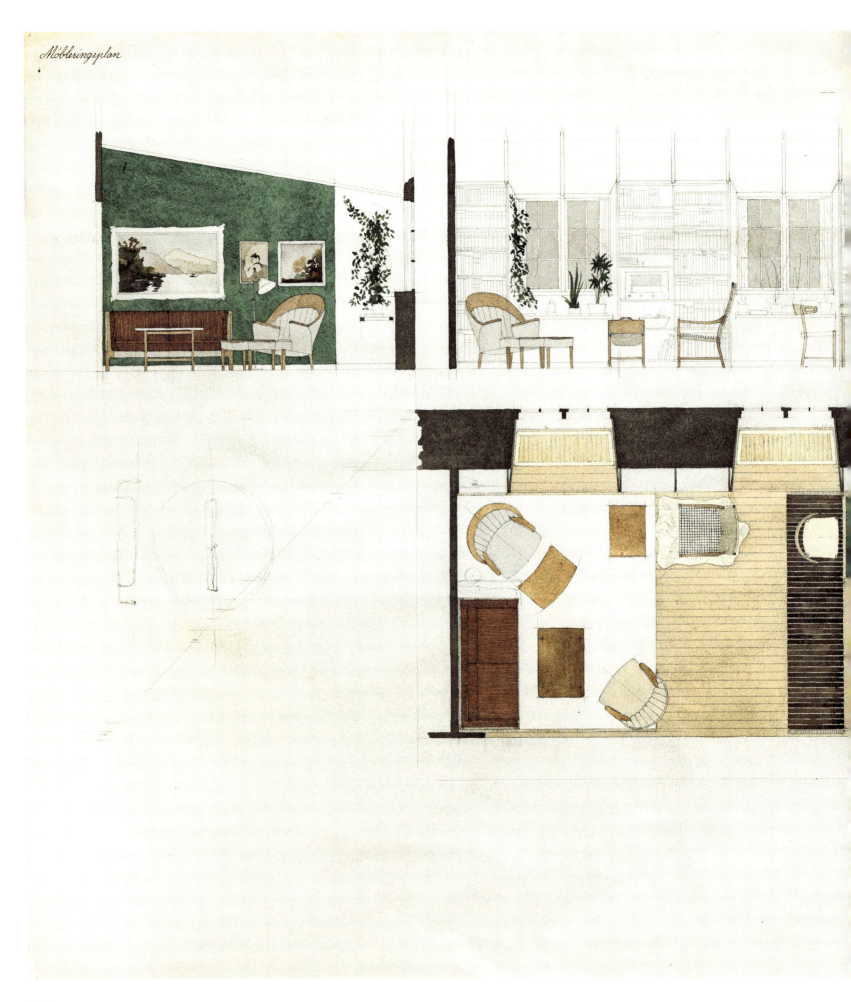

Möbleringsplan

Living room
Floor plan and elevations
Pencil, pen and watercolour
Undated

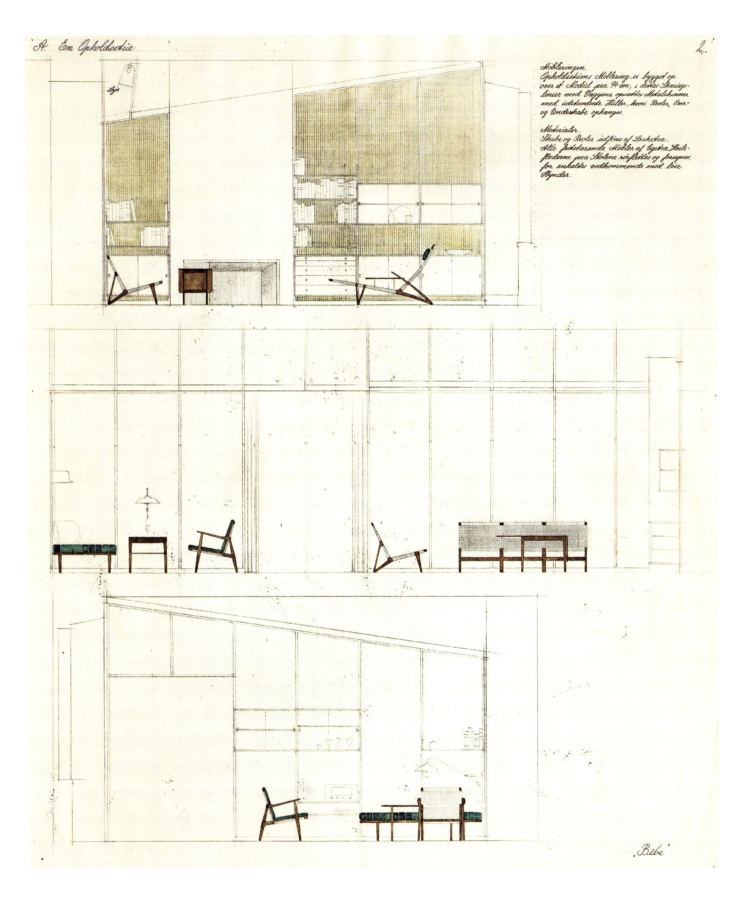

Living room
Elevations
Pencil, pen and watercolour
Undated

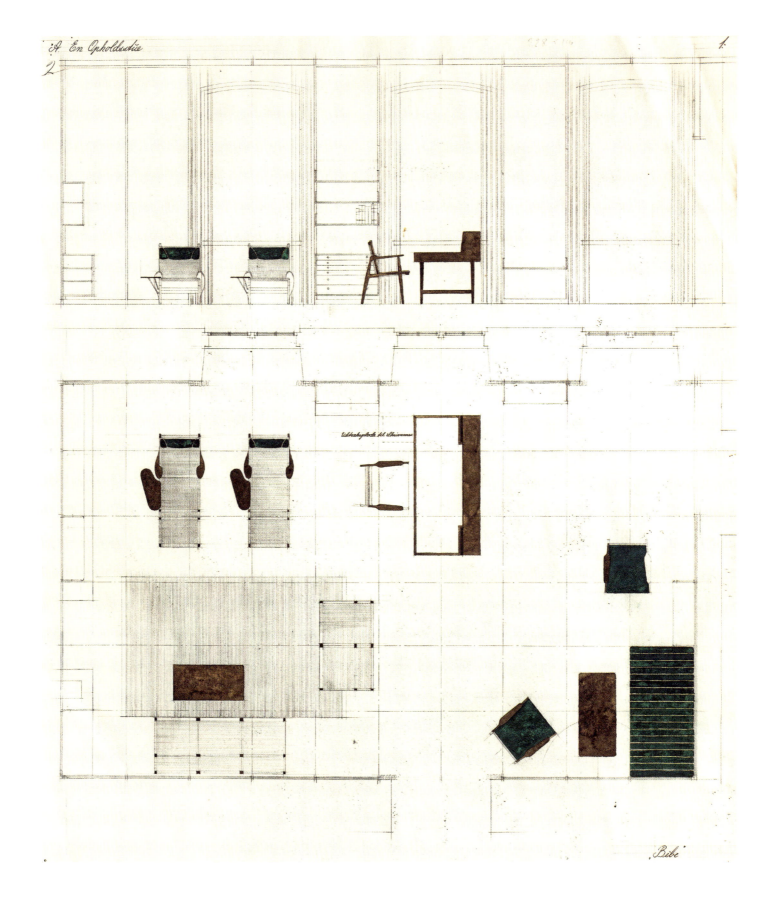

Living room
Floor plan and elevation
Pencil, pen and watercolour
Undated

Wallpapers

Around the time Wegner was a student at The School of Decorative Art, the question of whether it was progressive to wallpaper one's home or not was hotly debated. Functionalism prescribed clean, bright walls, so if wallpaper were to enter private homes again, it would have to be revolutionised – certainly from the point of view of architects, artists and designers. This gave rise to a small production of so-called 'artist's wallpapers', which up through the 1930s was driven forward by competitions issued by, for example, The Danish Society of Arts and Crafts and Industrial Design or the wallpaper factories. The drafts for wallpaper designs we know from Wegner's hand date either from his student days or from competitions in the late 1930s and early 1940s. As far as is known, none of them were put into production.

Wallpaper design
Watercolour
Undated

Sketch for wallpaper design
Watercolour
Undated

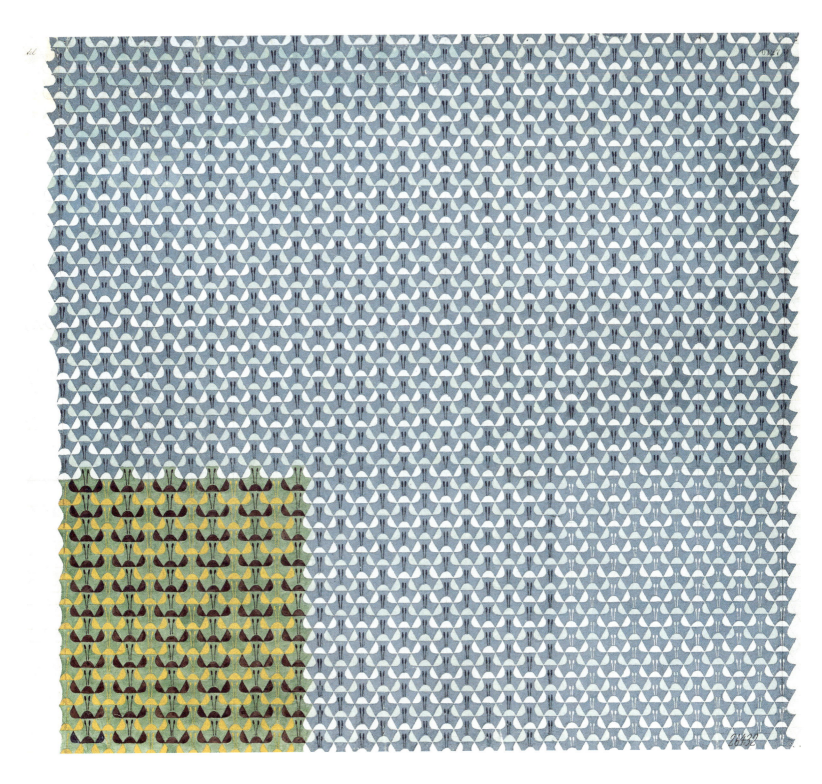

Wallpaper designs
Watercolour
Undated

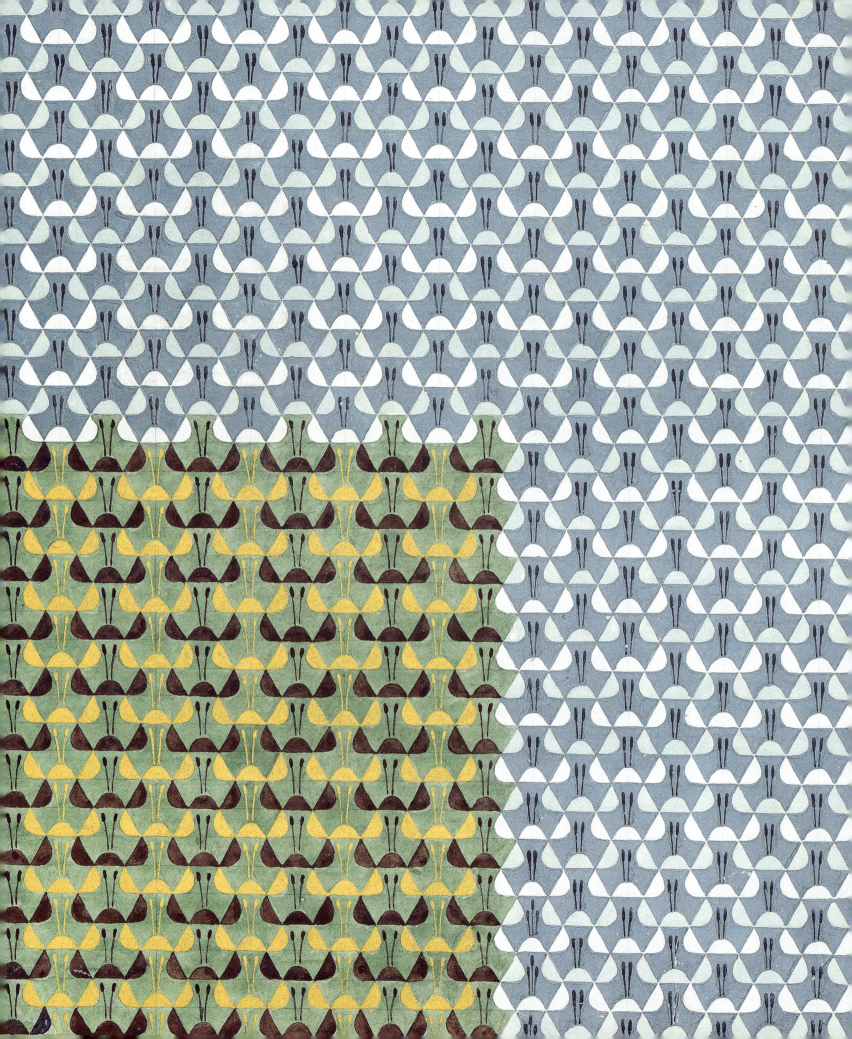

pp. 157-161

Wallpaper designs
Watercolour
Undated

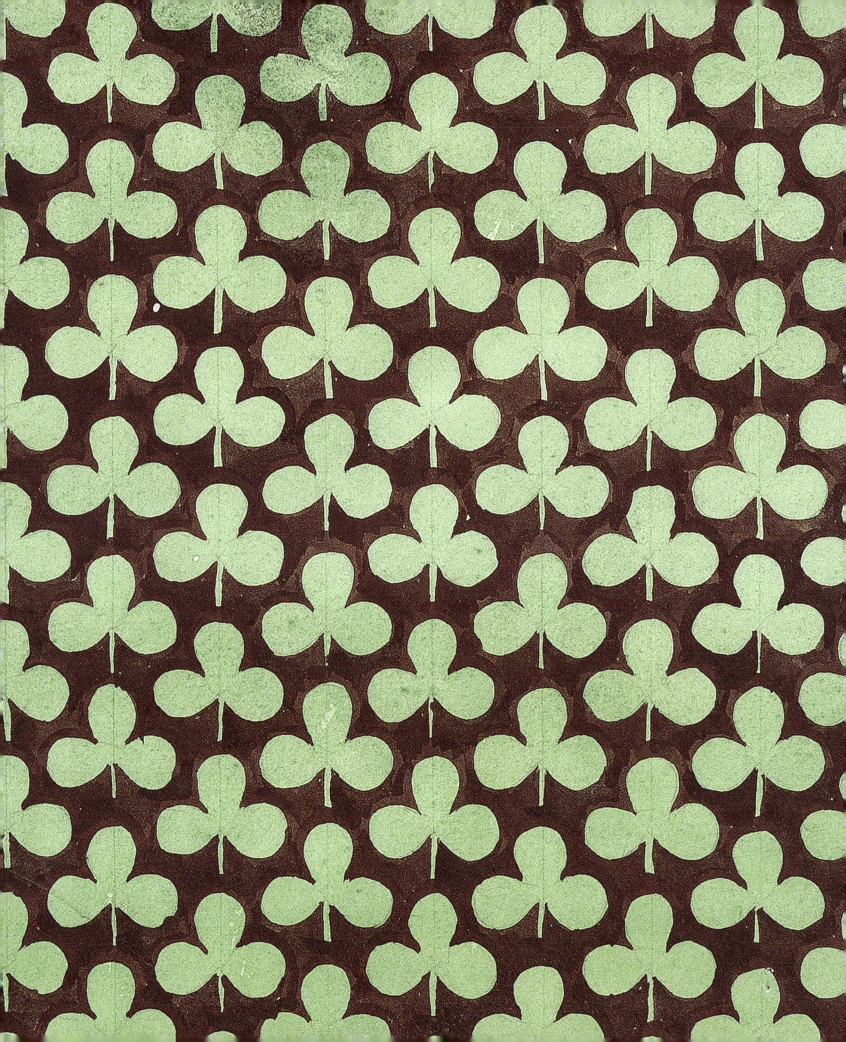

Sketch for wallpaper design
Watercolour
Undated

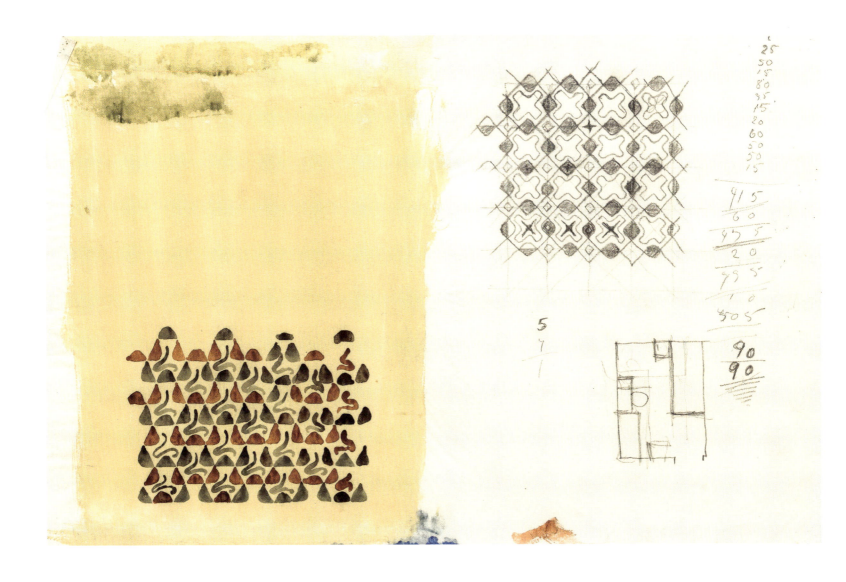

Wallpaper designs
Watercolour
Undated

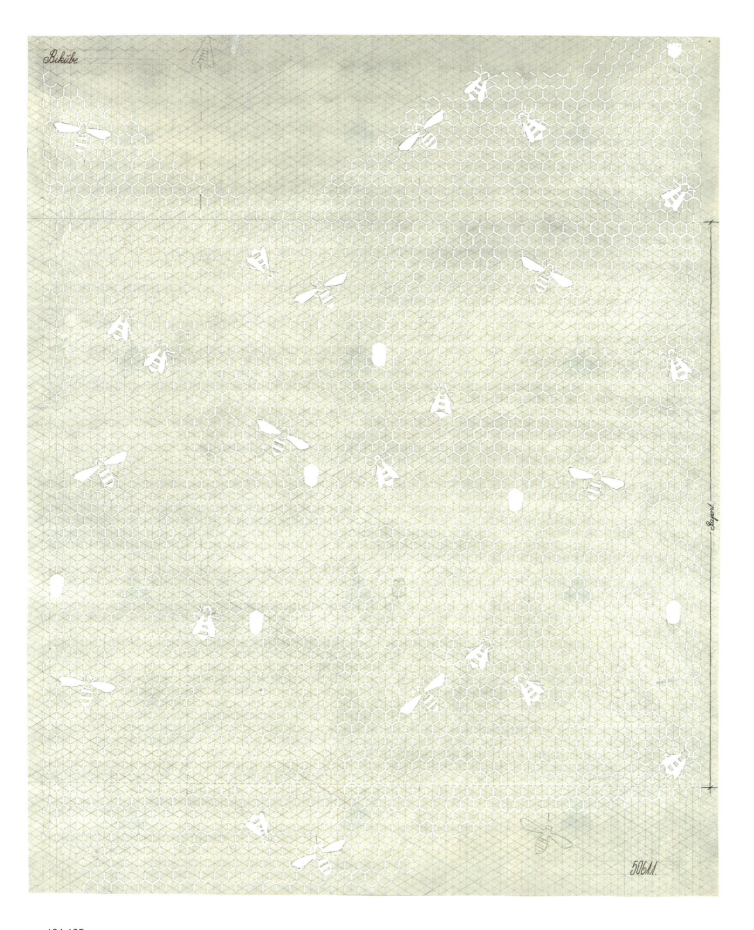

Wallpaper design
Watercolour
Undated

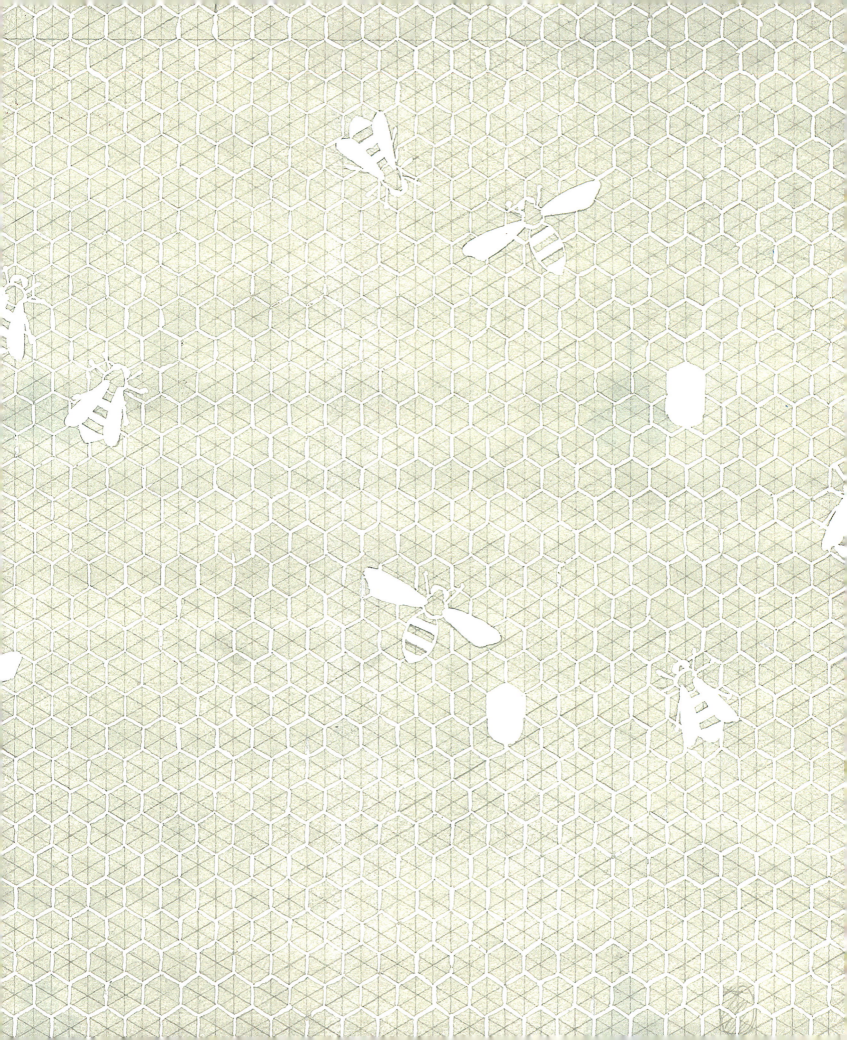

Objects

Wegner's ability to use watercolour as a communicative medium truly came into its own when he entered design competitions in the late 1930s and early 1940s. Those who won first, second or third place received a cash prize, which made for a not insignificant supplement to the household purse. Receiving an award also meant receiving publicity in the press, another key consideration for an upcoming young designer. Hence, Wegner took part in competitions that extended beyond furniture design, submitting proposals for a range of different objects such as cutlery, lamps and teapots.

Cutlery, submission for design competition
Elevations
Pencil, pen and watercolour
Undated

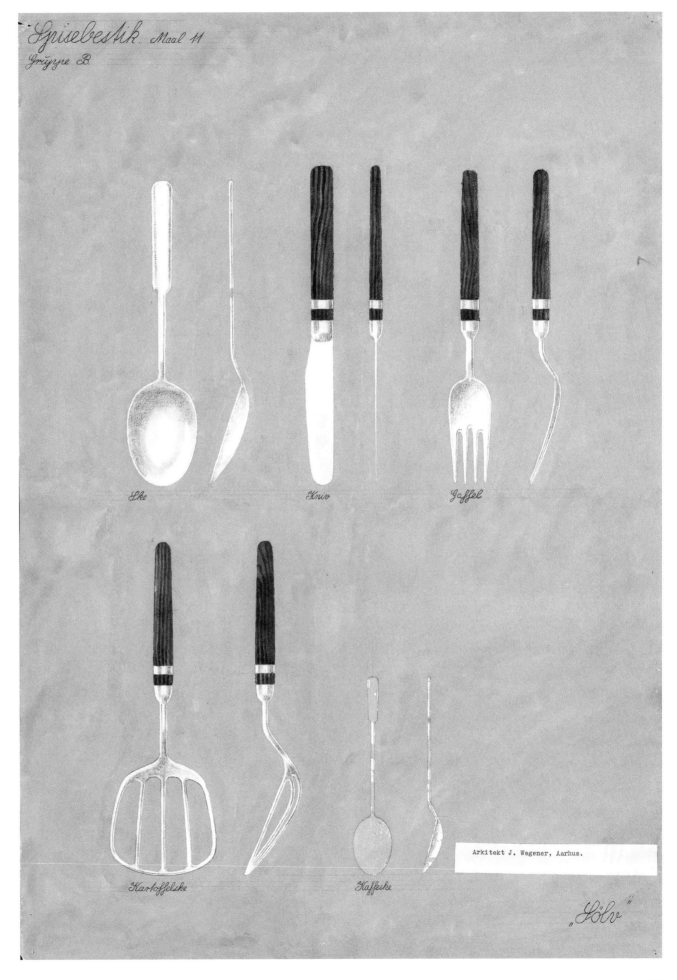

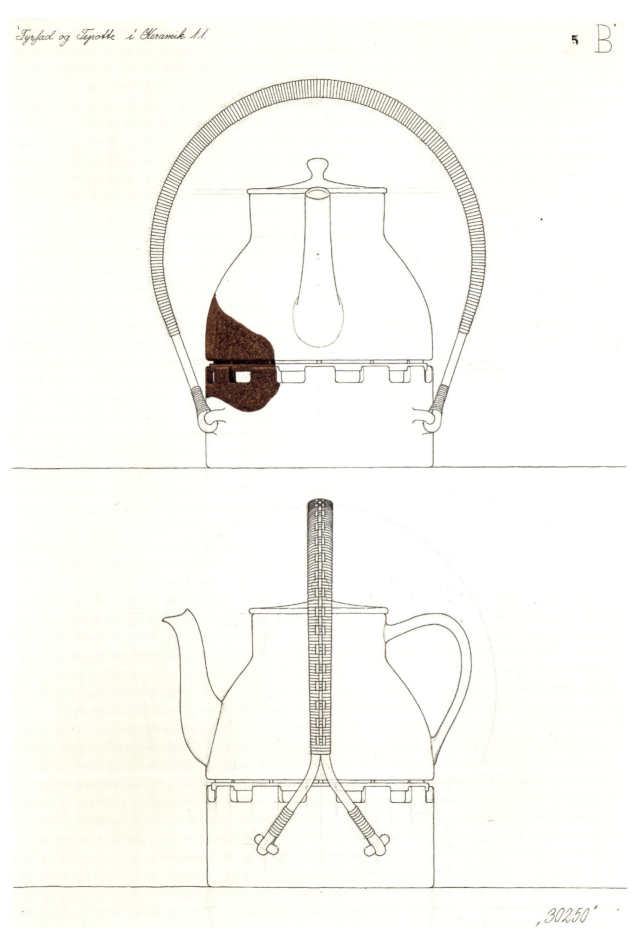

Ceramic tealight holder and teapot
Elevations
Pencil, pen and watercolour
Undated

Ceramic teapot
Plan and elevations
Pencil, pen and watercolour
Undated

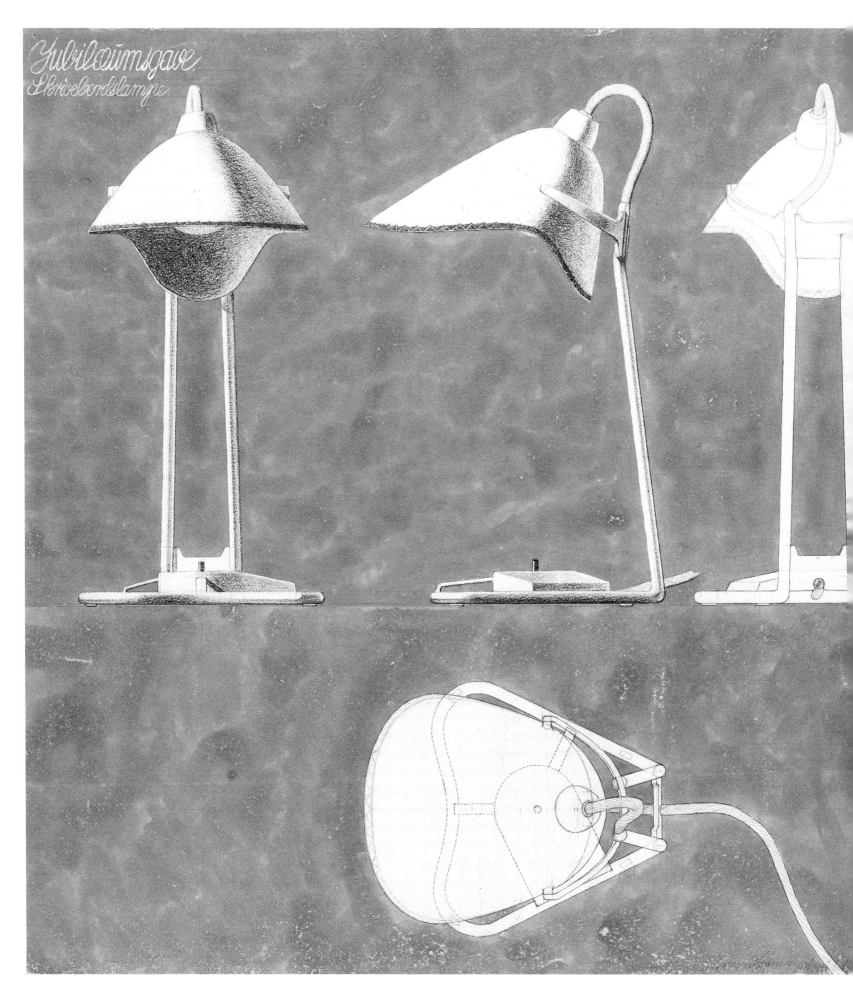

Desk lamp, anniversary gift
Plan and elevations
Pencil, pen and watercolour
Undated

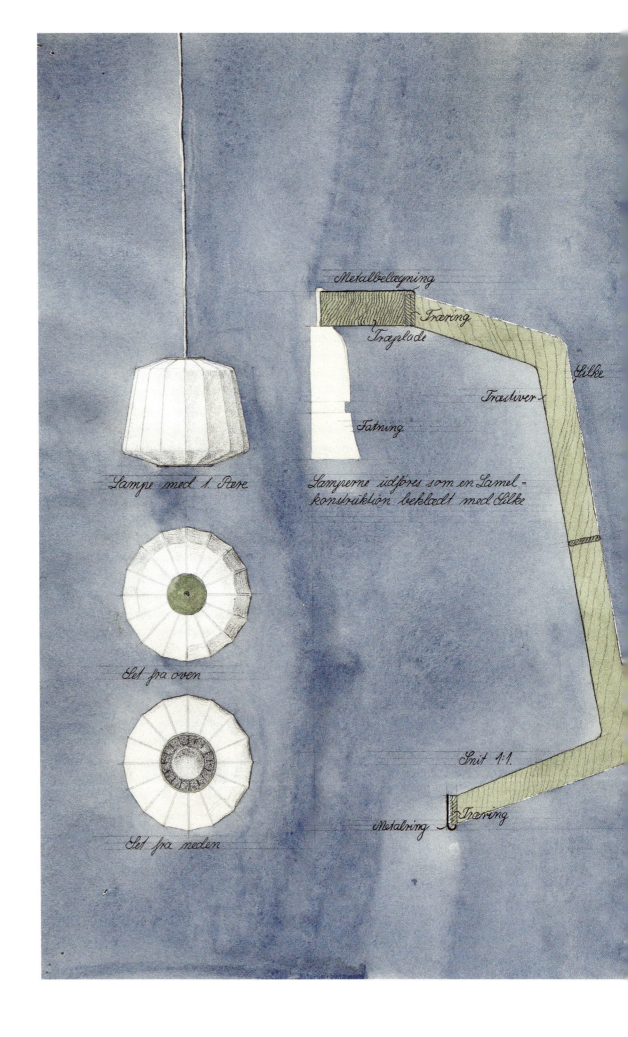

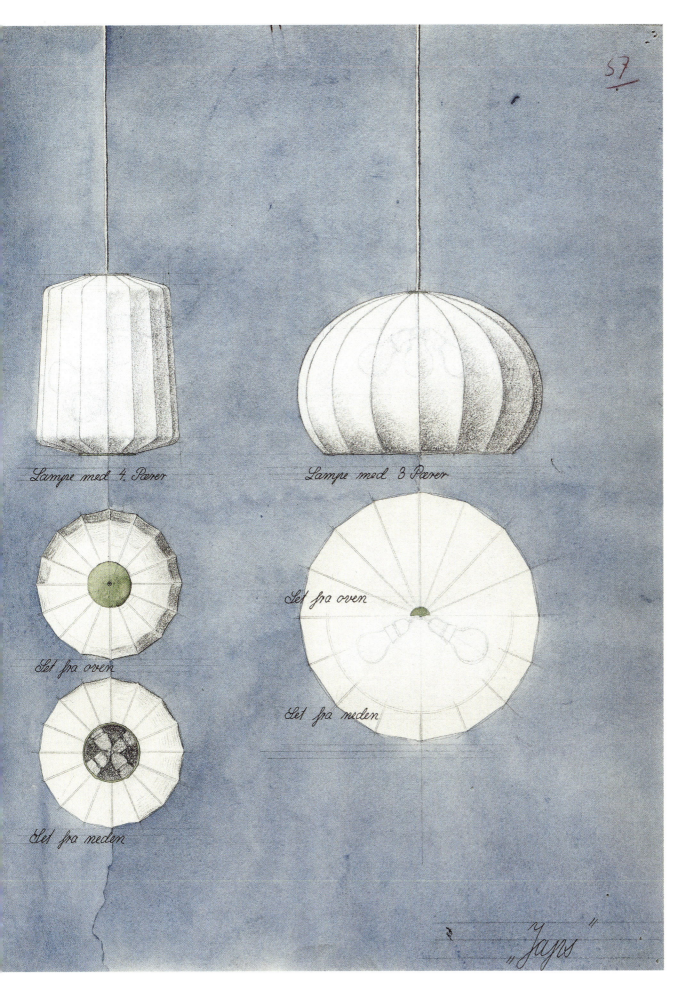

Lamp
Plans, sections and elevations
Pencil, pen and watercolour
Undated

Biography

1914, Hans and his older brother Heini

1929, Wegner's first chair

1933, Hans' father Peter Wegner

1914 — Hans Jørgensen Wegner is born on 2 April 1914 in Tønder, which at the time was part of Germany. His parents are Nikoline and Peter Wegner, and the couple already had a son, Heini. The couple are part of the Danish-minded community in the region. The father runs a shoemaker's shop at Smedegade 12, where the family also lives.

1920 — In the year of the Reunification, when the Southern Jutland region rejoined Denmark, Wegner begins his schooling at Tønder Statsseminariums Øvelsesskole. His teachers include the young Marius Jacobsen, with whom Wegner stays in touch until Jacobsen's death many years later.

Wegner leaves school after having completed the seven years of schooling compulsory at the time.

1928 — Enrols at the local technical school run by the Tønder Craftsmen's Association (Håndværkerforeningen) as a cabinetmaker's apprentice, having been apprenticed to master cabinetmaker H.F. Stahlberg.

1929 — Designs and makes his first chair in Tønder.

Carves sculptures from oak wood sourced from demolition sites.

1932 — Qualifies as a fully trained cabinetmaker.

Works as a cabinetmaker at H.F. Stahlberg until May 1935.

1933 — Wegner's father builds a house in Østergade 4, and the family moves in there.

1935

Wegner is called up for compulsory military service. He is stationed at Høvelte Barracks in North Zealand.

1936

Enrols at the Technological Institute (Teknologisk Institut) in Copenhagen for a three-month course as a cabinetmaker. Then enrols at The School of Decorative Art (Kunsthåndværkerskolen) located in what is now Designmuseum Denmark. The head of the school is cabinetmaker and architect Orla Mølgaard-Nielsen.

Meets Børge Mogensen, and the two form a lifelong friendship.

1938

Still a student, Wegner participates for the first time at The Cabinetmakers' Guild Exhibition (Snedkerlaugsudstillingen), presenting a suite of dining room furniture and an armchair. The pieces are created in collaboration with master cabinetmaker Ove Lander.

Accepts an appointment at Arne Jacobsen and Erik Møller's joint temporary design studio in Aarhus, where they are in the process of building a new City Hall. Wegner ends up being assigned the extensive task of designing all the furnishings for it.

Erik Møller also hires Wegner to design the furniture for the Nyborg Library, on which Møller is the architect together with Flemming Lassen.

1939

Nyborg Library is inaugurated.

Wegner travels to Finland to view functionalist architecture, presumably in the company of his friend Børge Mogensen.

1940

Marries Inga Helbo, who works as a bookkeeper.

Enters into collaboration with the cabinetmaking workshop Johannes Hansen in Copenhagen.

1935, Wegner as a soldier

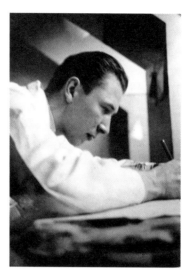

1936, Wegner as a student

1938-1939, Nyborg Library

1940, the wedding couple Inga and Hans J. Wegner

1944, "Peter's chair"

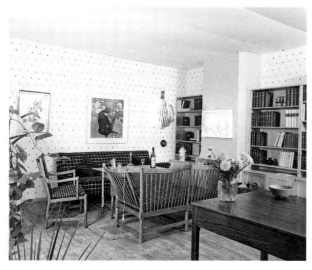

1945, The Cabinetmakers' Guild Exhibition

1941	Enters into a contract with the office furniture company Planmøbler. The Aarhus City Hall is inaugurated.
1942	Creates living room furniture featuring carvings for the recurring exhibition and trade fair Købestævnet in Fredericia in collaboration with master cabinetmaker Mikael Laursen. The furniture constitutes an effort to keep the art of woodcarving alive.
1943	Wegner ideally wanted to return to Copenhagen to finish his training at The School of Decorative Art, but finding somewhere to live proves very difficult. Instead, he sets up business as an independent architect in Aarhus. Works on various versions of the China Chair, which is intended to expand the furniture company Fritz Hansen's range of steam-bent wooden furniture.
1944	Makes a children's chair for his godson, Børge Mogensen's son Peter. The design later becomes known as 'Peter's chair'. Mogensen, who heads the furniture department at FDB, puts it into production. Wegner also designs the rocking chair J16 for FDB. Fritz Hansen puts a version of the China Chair (FH4283) into production. It later becomes known as the Curly China Chair. Wegner designs the Fish Cabinet and cuts the wood inlay decorating its interior himself. Capturing childhood memories from the Vidå river in Tønder, the Fish Cabinet is exhibited at Johannes Hansen's stand at The Cabinetmakers' Guild Exhibition.
1945-1946	Collaborates with Børge Mogensen on designing and exhibiting furniture at The Cabinetmakers' Guild Exhibitions.

1946 Moves to Copenhagen, where he becomes a teacher at The School of Decorative Art. Is employed by architect Palle Suenson to design ship interiors. When time allows, Wegner works on his own furniture designs too.

1947 Designs the Peacock Chair, which he completes together with Nils Thomsen, foreman at Johannes Hansen's company.

Wegner and Inga's first daughter, Marianne, is born.

1948 Submits proposals for the New York-based Museum of Modern Art's design competition for affordable furniture for smaller homes.

1949 Creates three iconic chair designs: the Tripartite Shell Chair, the Folding Chair and the Round Chair for The Cabinetmakers' Guild Exhibition. Johannes Hansen puts the Folding Chair and the Round Chair (JH501/503), which would later become known as The Chair, into production.

Gets in touch with the Odense company Carl Hansen and designs the Wishbone Chair.

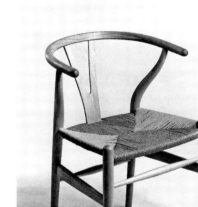
1947, Peacock Chair

1949, Wishbone Chair

1949, Tripartite Shell Chair

1949, Round Chair

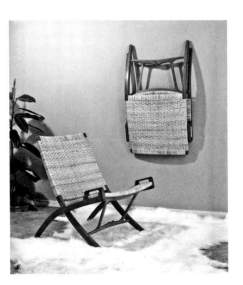
1949, Folding Chair

1949-1953

Works as an exhibition architect for The National Association of Danish Arts and Crafts (Landsforeningen Dansk Kunsthåndværk).

1950

1950, Flag Halyard Chair

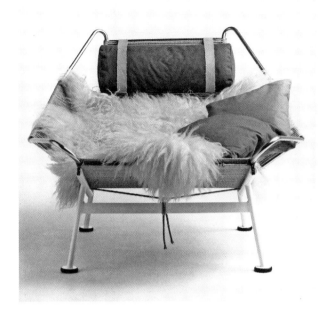

The American magazine Interiors runs an eight-page feature from the Danish Cabinetmakers' Guild exhibition in their February issue, including several full-page photos of Wegner's furniture. The publicity creates demand for the Round Chair, especially from America.

Designs the Flag Halyard Chair, which is put into production by the North Jutland company Getama.

Wegner's daughter Eva is born.

1951

Designs the Papa Bear Chair, which is put into production at A.P. Stolen. Also designs the Valet Chair (with four legs).

1951, Papa Bear Chair

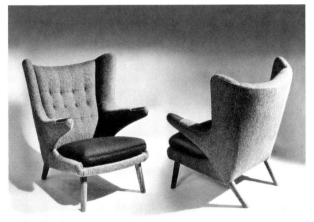

Alongside Finnish designer Tapio Wirkkala, Wegner is the first to win the newly established Lunning Prize.

Danish-American Frederik Lunning owns a large Nordic design store on 5th Avenue in New York called Georg Jensen Inc. The store contributes significantly to Wegner's designs becoming widespread and well received in America.

Wegner receives the Grand Prix at the Triennale in Milan.

1951, Valet Chair

1951, Wegner is awarded the Lunning Prize

The sales organisation Salesco (Sales Company) arises as a collaborative venture involving the five factories manufacturing Wegner's designs: Getama, Ry Møbler, A. Tuck, A.P. Stolen and Carl Hansen & Søn.

Moves to a terraced house in Gentofte, where the family lives until 1965.

1952	Designs the Cow Horn Chair.
1953	By this point, daughters Marianne and Eva are deemed old enough to have a prolonged stay with their grandparents and, later, their uncle Heini and aunt Anni in Tønder, enabling Wegner to spend his Lunning Prize grant on a months-long trip to America and Mexico with his wife, Inga. Here he visits furniture companies and is offered various design assignments, which he declines.
1954	Awarded a gold medal at the Triennale in Milan.
	The large joint Nordic exhibition project Design in Scandinavia begins its three-year-long tour in America and Canada. Wegner's Round Chair (The Chair) is featured in the exhibition.
1955	Wegner designs the Swivel Chair based on chief physician Egill Snorrason's professional insight into bodies affected by polio.
1956	Receives the Eckersberg Medal, a prestigious Danish award for fine and applied art.
1957	Begins work on designing his own house on a plot of land in Gentofte close to the area affectionately nicknamed 'The Architects' Marsh'.
1958	Designs the interior of a conference room in the UNESCO building in Paris. Many other international architects are assigned similar tasks.
	Johannes Hansen's company relocates, moving out of central Copenhagen to Gladsaxevej in Søborg.
	Wegner designs the Airport Chair, which will go on to be featured in the Copenhagen Airport at Kastrup.

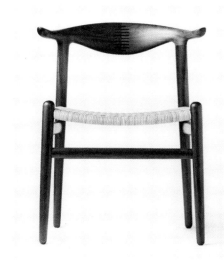

1952, Cow Horn Chair

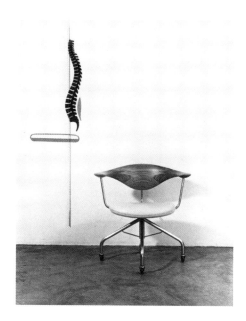

1955, Swivel Chair

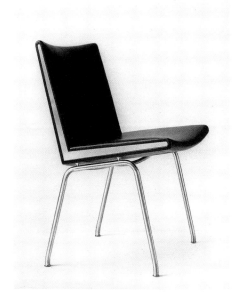

1958, Airport Chair

1959, Wegner exhibition in New York

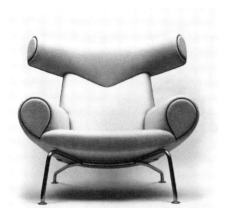

1960, Ox Chair

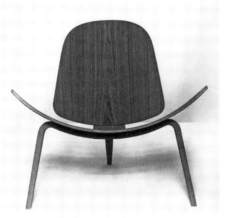

1963, Three-Legged Shell Chair

1959 Travels to New York, where the son of Frederik Lunning, Just Lunning, has arranged a major exhibition of Wegner's designs in the Georg Jensen Inc. store.

Wegner is the first foreigner ever to receive the distinction of being elected a Royal Designer for Industry by the British Royal Society of Arts.

Designs his own holiday home.

1960 Designs the Ox Chair.

The furniture designer Bernt Petersen is briefly attached to Wegner's design studio.

In the USA, presidential candidates Richard Nixon and John F. Kennedy try out various chairs ahead of the nation's first-ever live televised election debate. They choose Wegner's Round Chair for the event. The publicity brings about a revival of the chair's popularity in the USA, and the later President Kennedy's name becomes associated with the Round Chair, which is also nicknamed the Kennedy Chair or, still, simply The Chair.

1961 Paul Hansen takes over the cabinetmaking workshop operated by his father, Johannes Hansen.

1963 Wegner designs the Three-Legged Shell Chair.

1965 On the occasion of the 50th anniversary of the Johannes Hansen cabinetmaking business, the company arranges a major exhibition about their collaboration with Wegner at their premises in Søborg. In collaboration with the publishing house Gyldendal, Johannes Hansen publishes the book *Wegner: En dansk møbelkunstner* (Wegner: A Danish Furniture Master).

Wegner designs the Minimal Chair (PP701) as a dining chair for his new home.

Moves into his newly built house in Gentofte.

Designs a series of library furniture used at a range of institutions, including Sorgenfrivang Library in Lyngby-Tårbæk Municipality.

1965, Minimal Chair

1967 The Copenhagen-based design cooperative and shop Den Permanente exhibits thirty-four recipients of the Lunning Prize, including Wegner.

1969 Receives the American Institute of Interior Designers' special award for 'continued outstanding achievement in quality and craftsmanship in the field of design'.

Wegner designs his first chairs for PP Møbler, which until this point had only been a subcontractor delivering the frame for the Papa Bear Chair.

1972 Johannes Hansen opens a showroom on Pistolstræde.

1973 Wegner's daughter Marianne begins working with her father at his design studio.

1975 Wegner and Marianne win a competition launched by the lighting company Louis Poulsen, inviting designs for 'lighting in historically and architecturally valuable environments'.

Designs the Ferry Chair for PP Møbler.

1975, street lamp

1977, Butterfly Chair

1982, PP75

1987, PP68

1977 Designs the Butterfly Chair for Getama.

1978 Exhibits at the furniture and design store Illums Bolighus alongside weaver Kim Naver.

1979 A major exhibition of Wegner's furniture is presented at Southern Jutland's art museum, Sønderjyllands Kunstmuseum, in Tønder, on the occasion of Wegner's 65th birthday. The exhibition is accompanied by a book, *Tema med variationer* (Theme with Variations).

1982 Receives the C.F. Hansen Medal.

Designs the table PP75.

1984 Designs the last of several rocking chairs, PP124.

1986 Designs the Circle Chair for PP Møbler.

1987 Receives the Danish Design Council's Annual Award (Dansk Designråds Årspris).

Designs the dining room chair PP68 for PP Møbler.

1989 Receives the Danmarks Nationalbank's Anniversary Foundation honorary award.

1994 The Danish Design Center opens a Wegner exhibition and publishes the book *Hans J. Wegner*.

1995 The Water Tower in Tønder, an exhibition venue affiliated with Sønderjyllands Kunstmuseum and Tønder Museum, is inaugurated, presenting the 'Gift of Chairs to Tønder' – a donation of thirty-seven chairs that Wegner and Inga bestow upon the town of Tønder.

1997 Is made an Honorary Doctor by the Royal College of Arts in London. Wegner turns up in person to receive the honour.

2007 Wegner dies.

2013 The Delegates' Lounge in the UN headquarters in New York is redesigned by Hella Jongerius, who includes the Peacock Chair as the only piece of furniture kept over from the old interior.

2014 On the occasion of Wegner's 100th birthday, Designmuseum Danmark opens the exhibition *Wegner: Just One Good Chair*, and the art museum in Tønder opens the exhibition *Hans J. Wegner. A Nordic Design Icon from Tønder*. Both museums publish catalogues to accompany the shows.

2020 An association for the establishment of a museum for Hans J. Wegner's furniture design is founded.

The association works towards establishing an independent museum for the man who may have been the greatest chair maker ever. The plan is to set it in on a former estate called Hestholm, a partly manmade 'island' in the Tønder Marsh.

2024 Architects Dan Stubbergaard, Alexander Ejsing and Mark Aron Thomsen from the design studio Cobe draw the future museum, which is expected to open in 2027/2028.

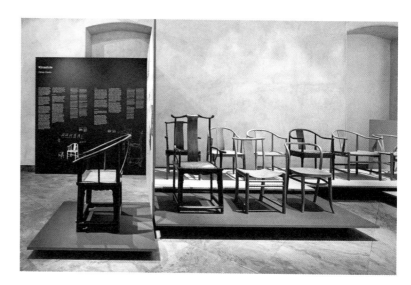

2014, Designmuseum Denmark presents the exhbition *Wegner: Just One Good Chair*

2020, the Hestholm estate in the Tønder Marsh will be transformed into a museum for Wegner over the coming years

Watercolours by Hans J. Wegner
© 2024 Anne Blond and Strandberg Publishing

Publishing editor: Nicholas Jungblut
Project manager: Sidsel Kjærulff Rasmussen
Photo editors: Anne Blond and Rasmus Koch Studio
Translator: René Lauritsen
Copy editor: Wendy Brouwer
Design and cover: Rasmus Koch Studio
Front cover: Hans J. Wegner: Competition Entry. Pencil, pen and watercolour. 1948. Photo: Ole Akhøj
Back cover: Hans J. Wegner: Fish Cabinet (detail). Pencil and watercolour. Undated. Photo: Ole Akhøj
The book is typeset in AG Book Pro
Paper: Munken Lynx 150 g
Image processing: Garn Grafisk
Printing and binding: Jelgavas Tipogrāfija
Printed in Latvia 2024
1st edition, 1st print run
ISBN 978-87-94102-56-8

Copying from this book may only take place at institutions that have entered into an agreement with Copydan and only within the terms and condition set down in said agreement.

Published in collaboration with
Foreningen Museum Wegner
Hostrupvej 4
6270 Tønder
www.museumwegner.dk

Strandberg Publishing A/S
Gammel Mønt 14
1117 København K
www.strandbergpublishing.dk

Photo credit

All photos: © Hans J. Wegners Tegnestue
with exception of:

Alvar Aalto Foundation – 10n
Bent Wilkens – 11ø
Børge Mogensen's studio – 17øtv
Design Museum Denmark. Photo: Pernille Klemp – 10ø, 188ø
EB Photo / Hans J. Wegner's studio I/S – 182nm, 182nth
Hans Ole Madsen – 10m
Kofoed photography – 182ntv, 184ø
Maarbjergs Atelier – 20ø, 181n
Mogens Gabs – 188n
Ole Akhøj – 14n, 17øth, 17n, 19n, 25-33, 37-71, 75-79, 83-97, 101-113, 117-129, 133-149, 153-165, 169-175
Scan from *Børge Mogensen – Simplicity and function* – 18ø
Schnakenburg & Brahl photography – 19m, 20n, 182ø, 183ø, 184m, 185m, 186, 187ø, 187m
The archive at the Danish Central Library for Southern Schleswig – 15ø
The photographers Nørmark – 182m
The Royal Danish Library – 12n
Wilstrup – 6

The editors have attempted to identify all the license holders for the illustrations used in this publication. If we have missed any, we kindly ask you to contact the publisher, and you will receive the standard fee.